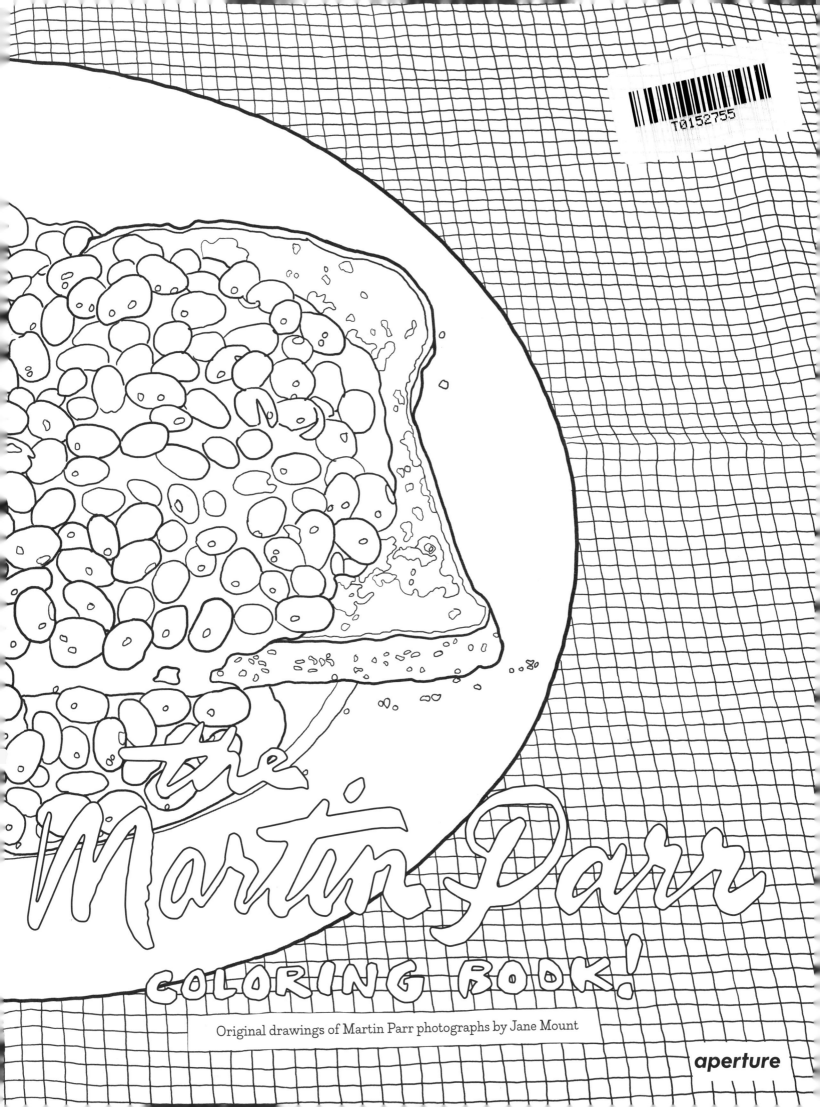

The Martin Parr

COLORING BOOK!

Original drawings of Martin Parr photographs by Jane Mount

aperture

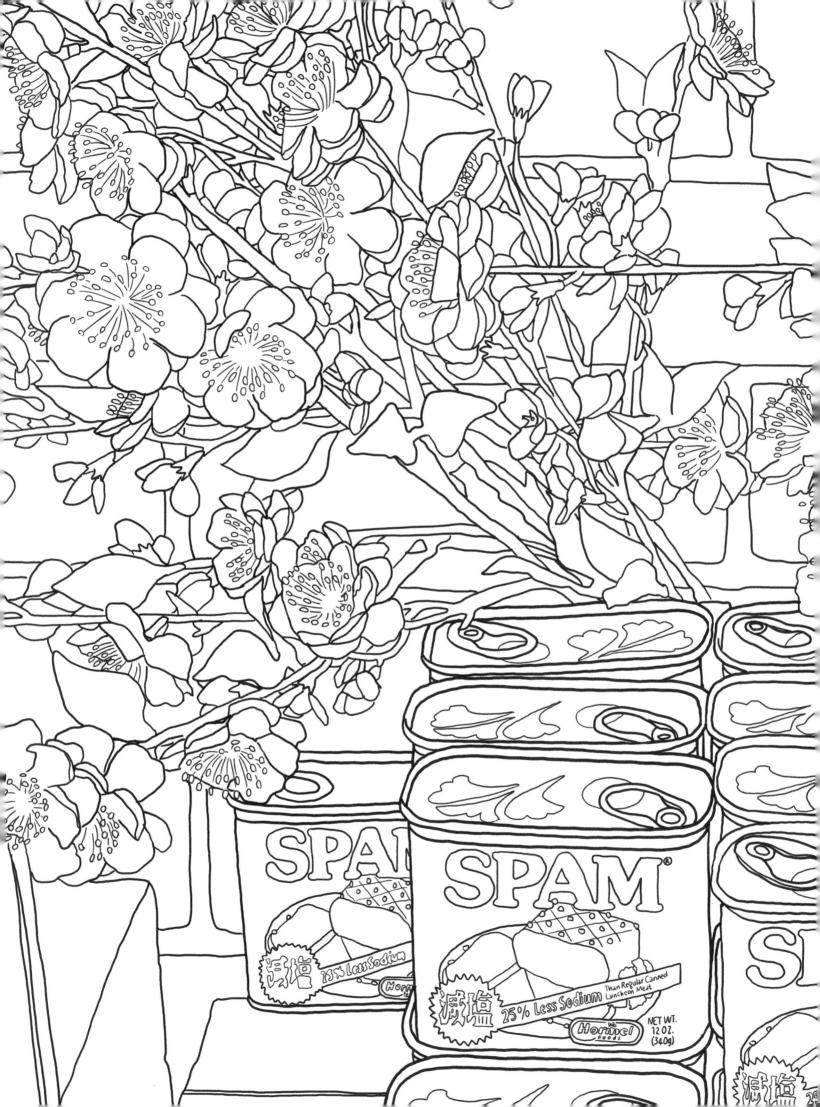

Dear Reader,

Thanks for becoming a fellow colorist as we journey through this collection of some of my most popular photographs—pictures of leisure to color at your leisure. So sharpen your pencils and get out your felt tips. You can even make them black and white!

You may ask, "Why a coloring book? Why now?" To which I respond, "Why not?" I like the challenge of personalizing the colors and making your own version. I'll be looking out for the best coloring, which you can share on Instagram, using #MartinParrColoring.

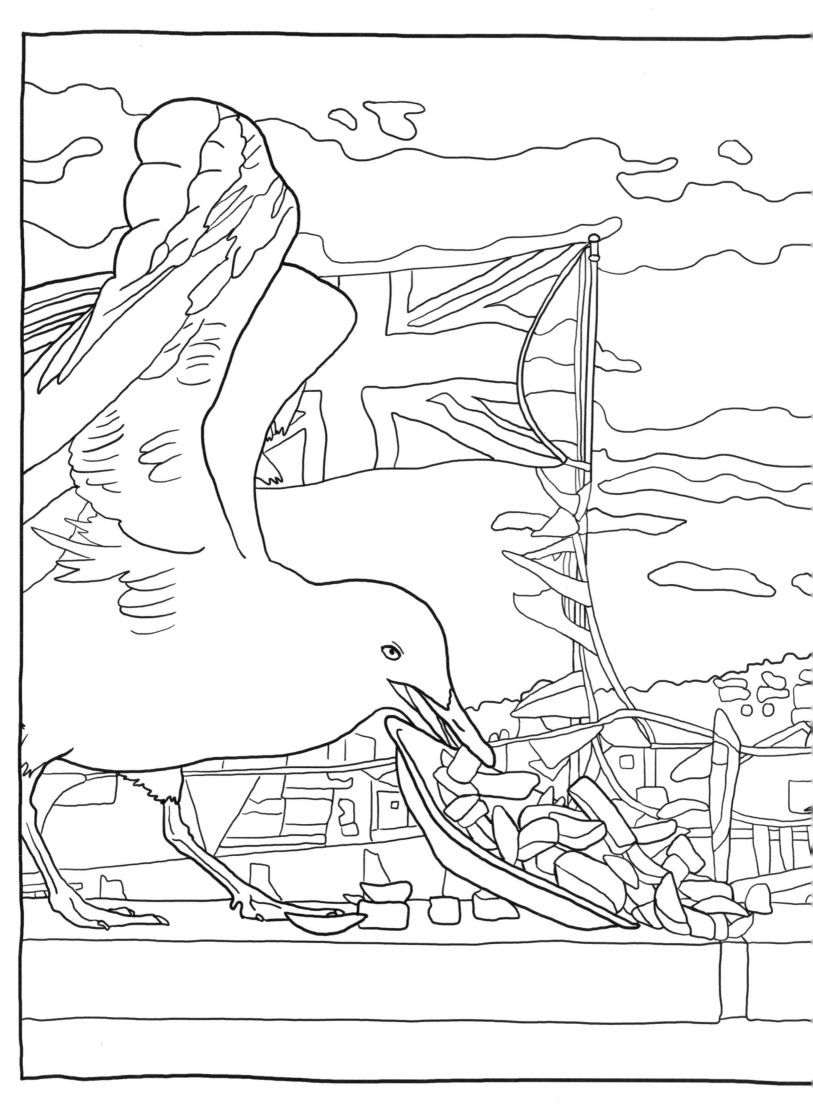

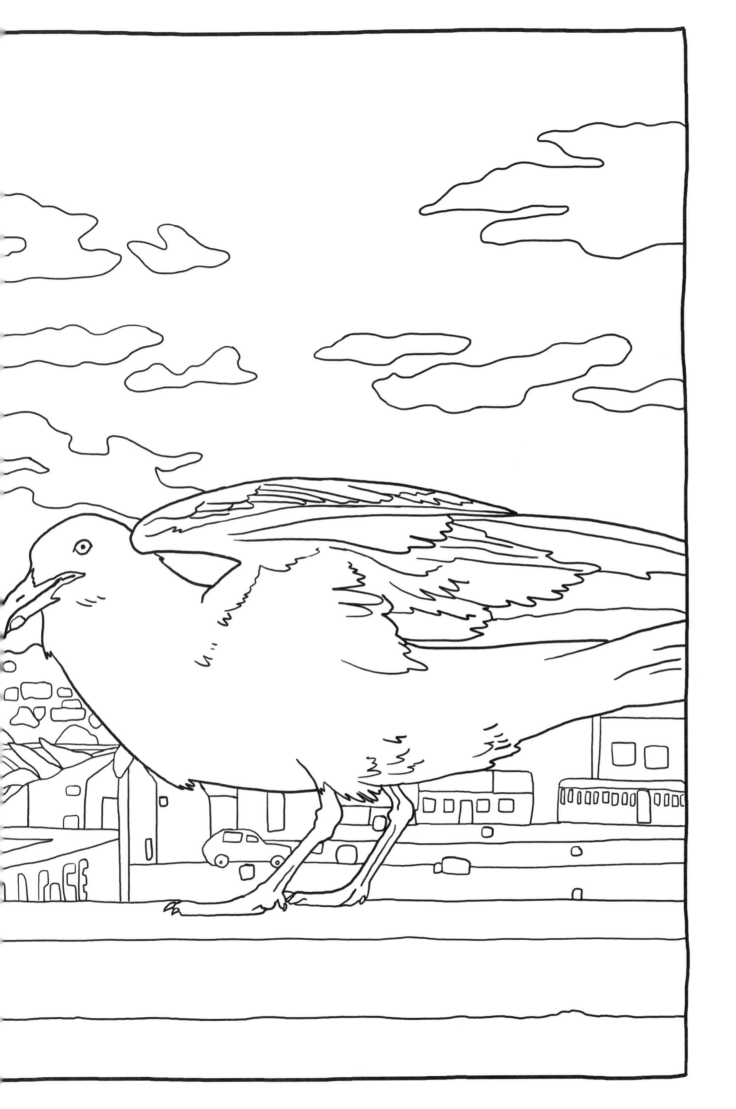

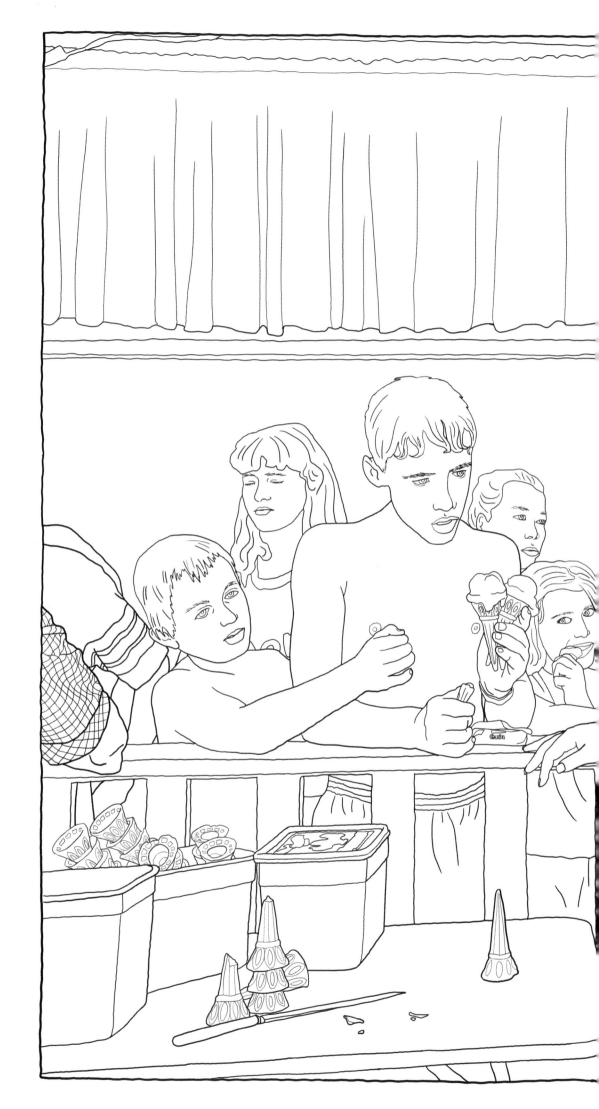

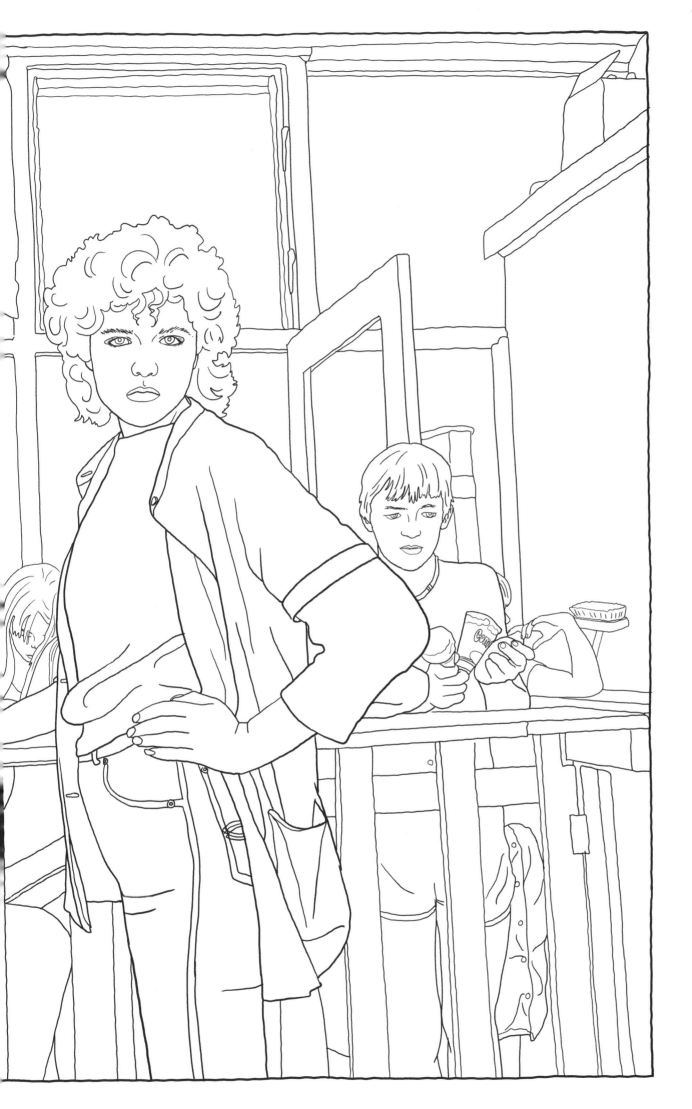

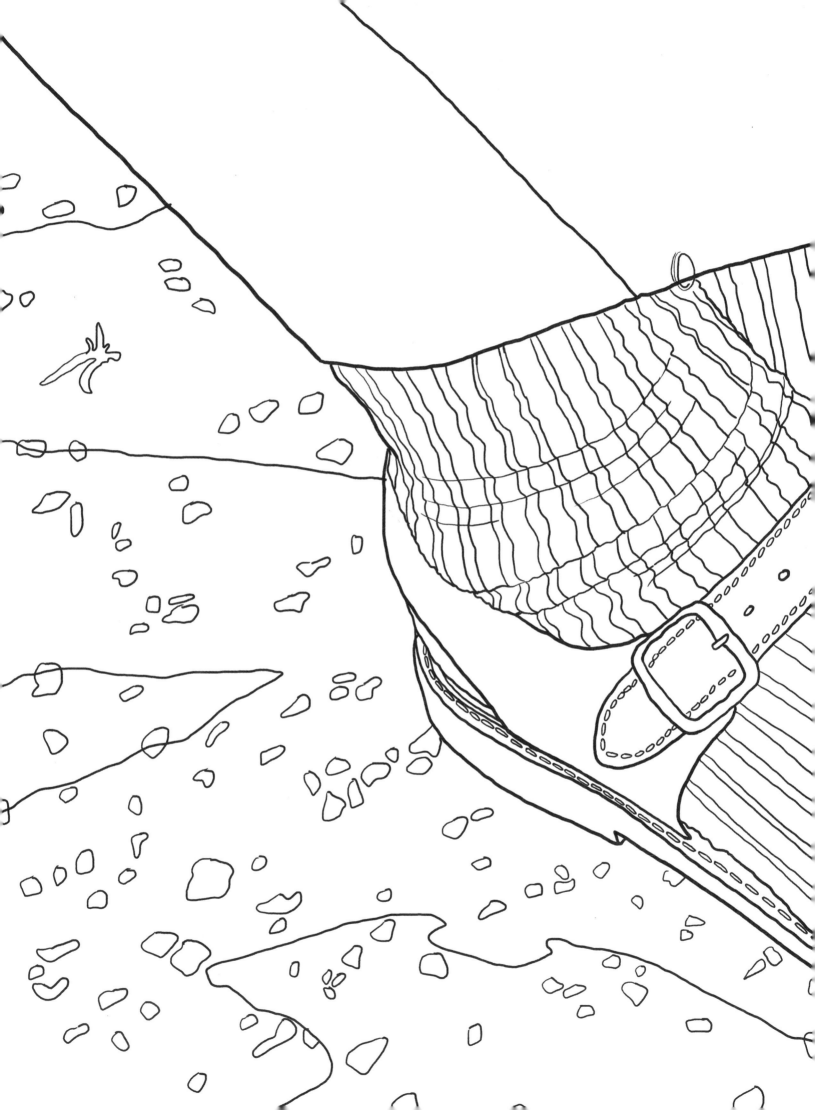

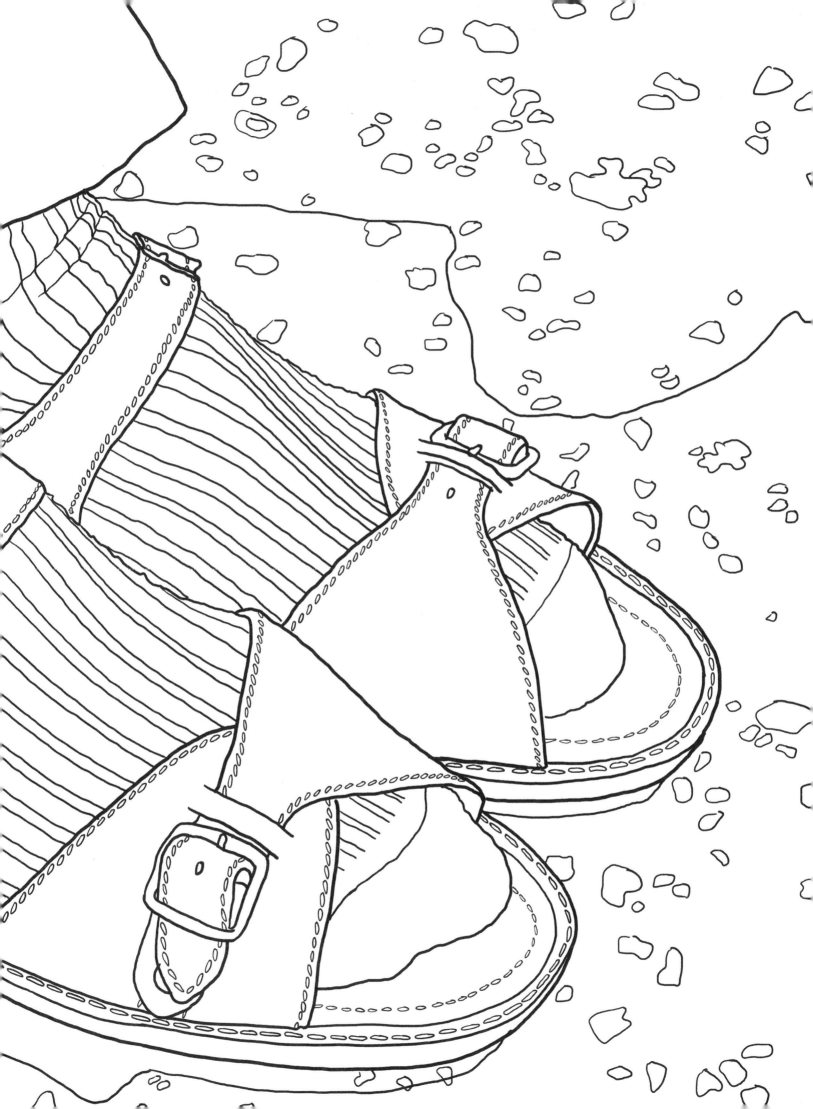

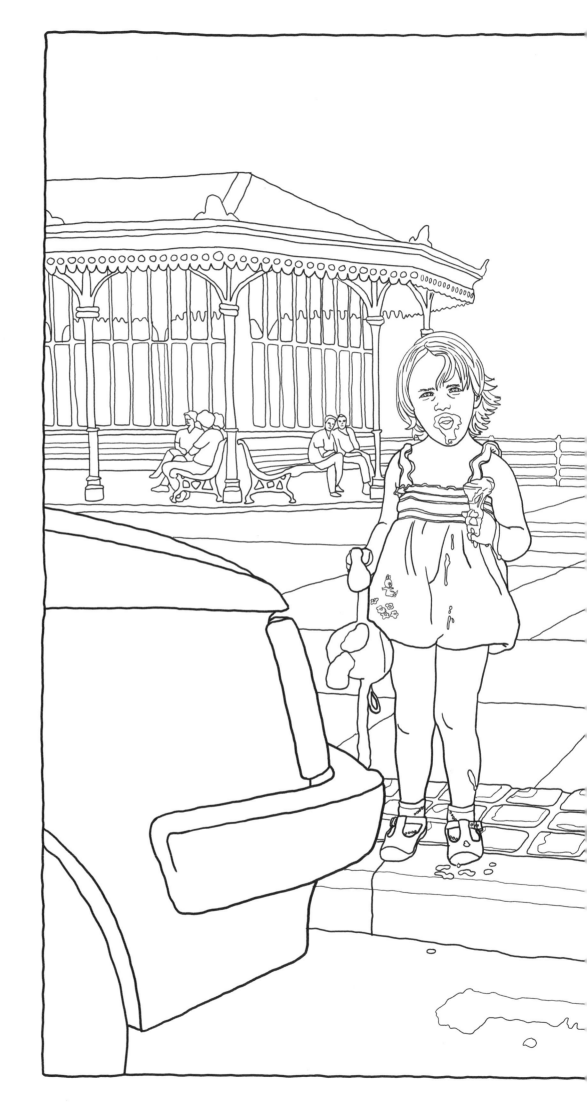

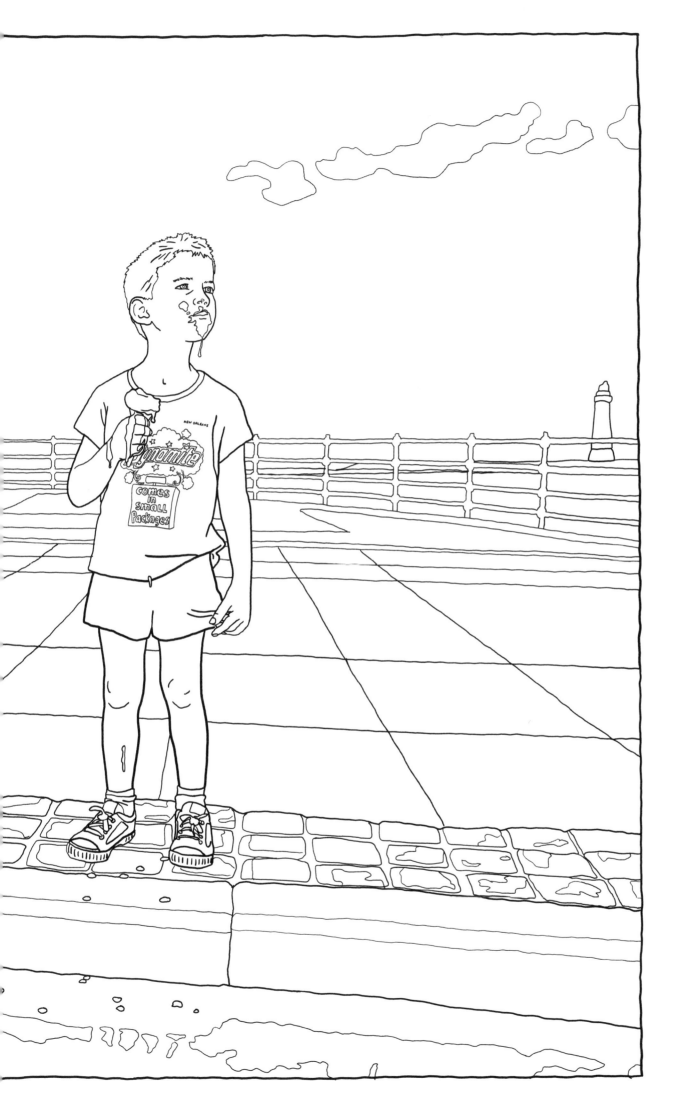

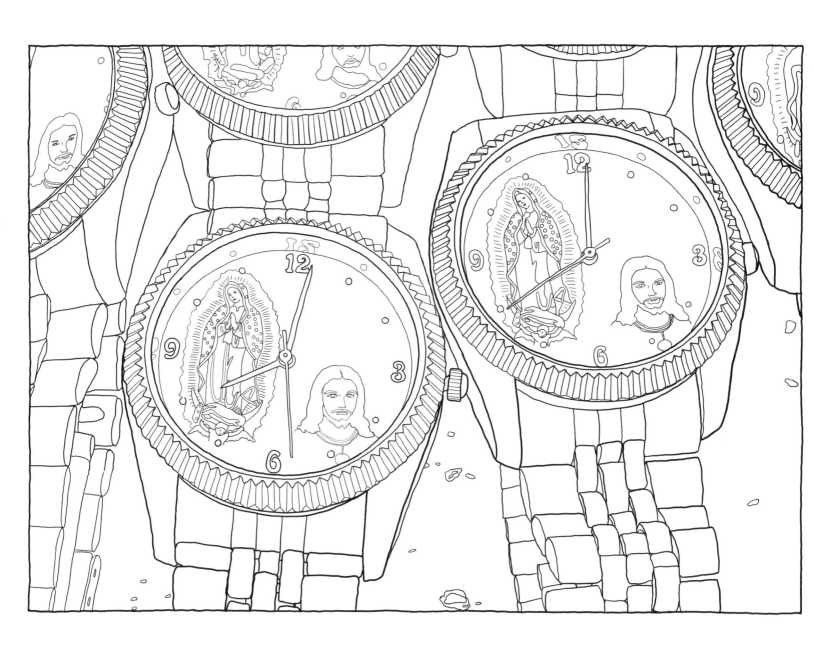

Mexico, 2003

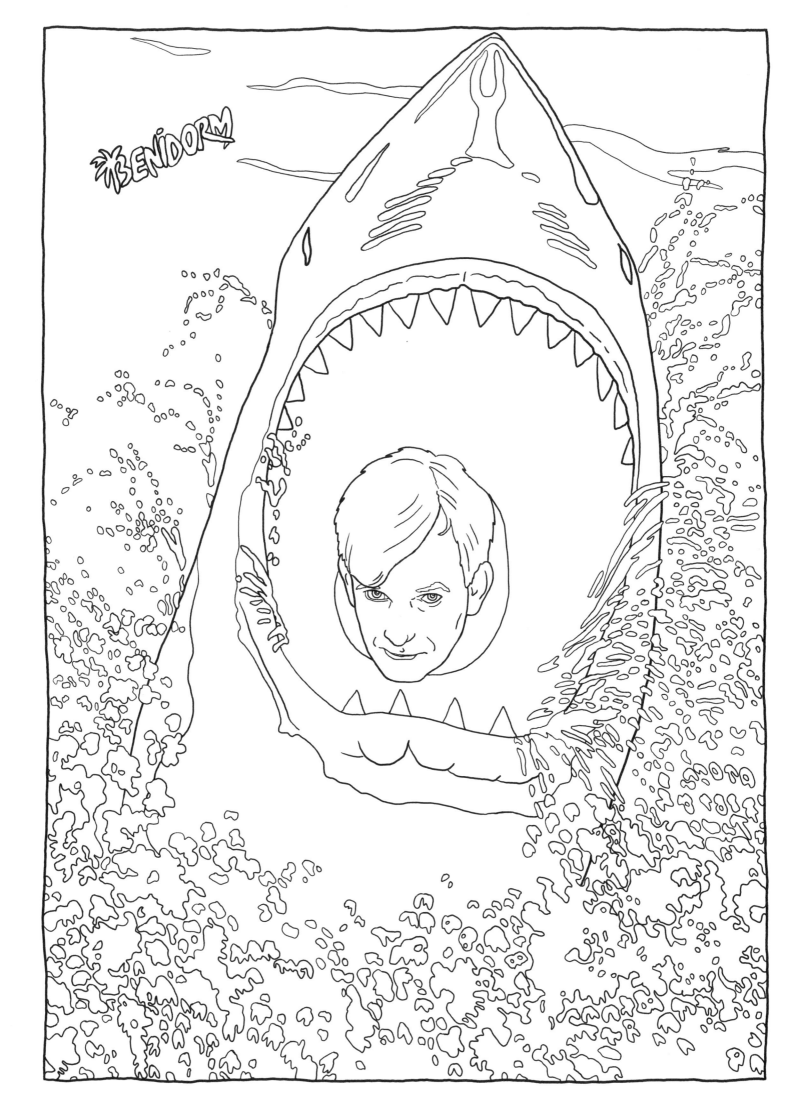

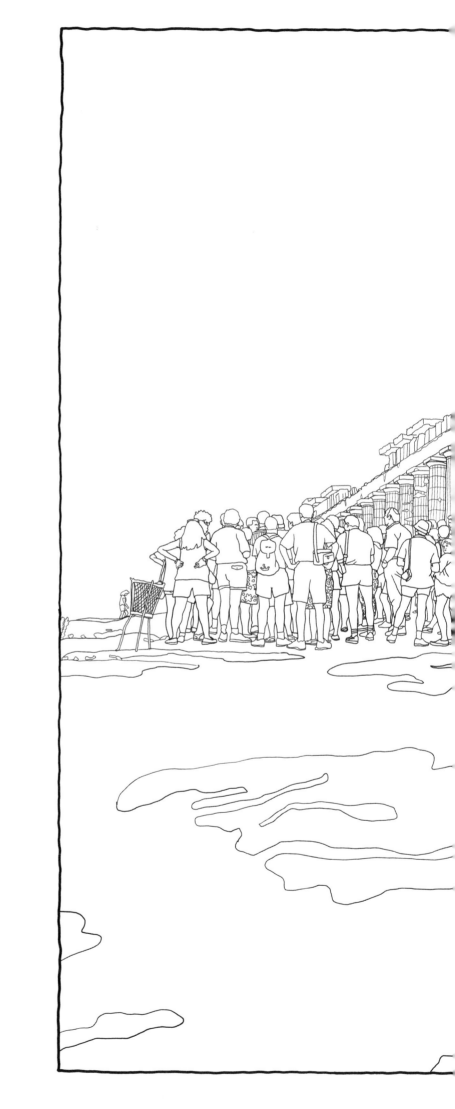

Acropolis, Athens, Greece, 1991

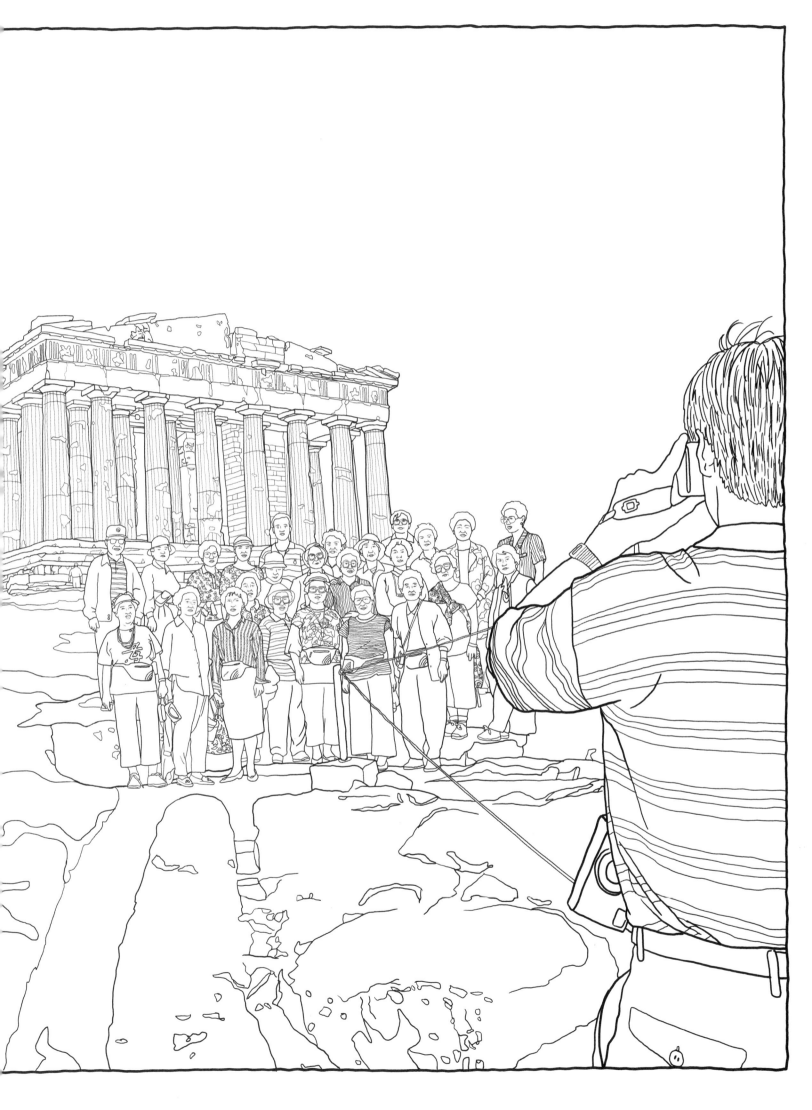

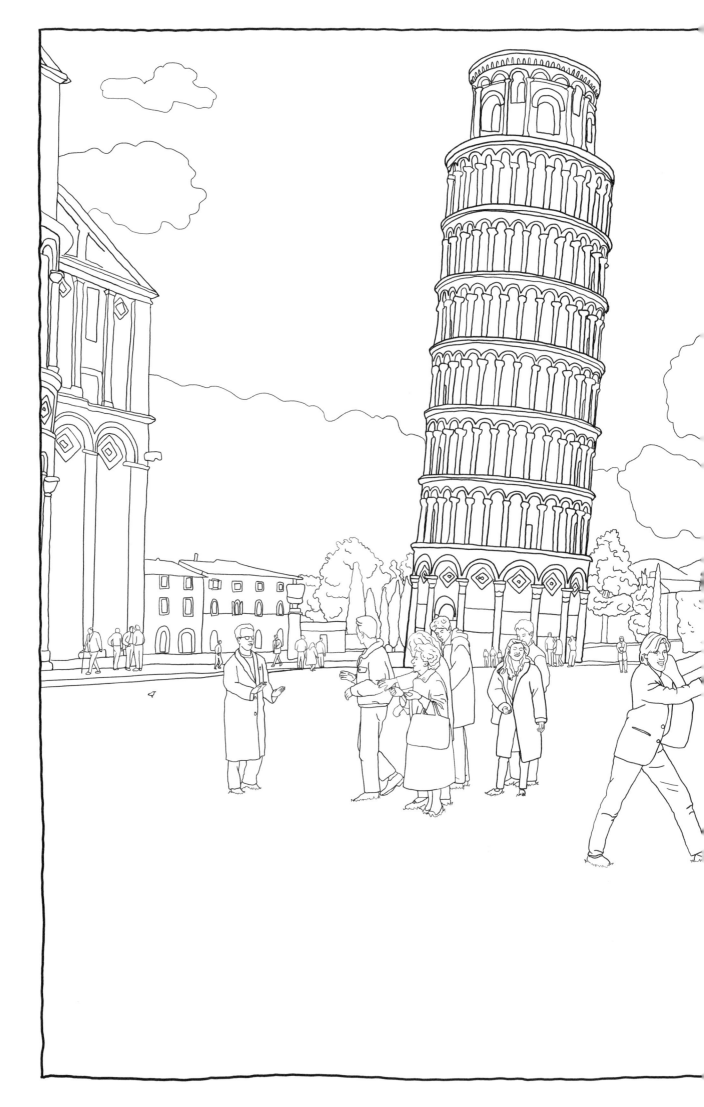

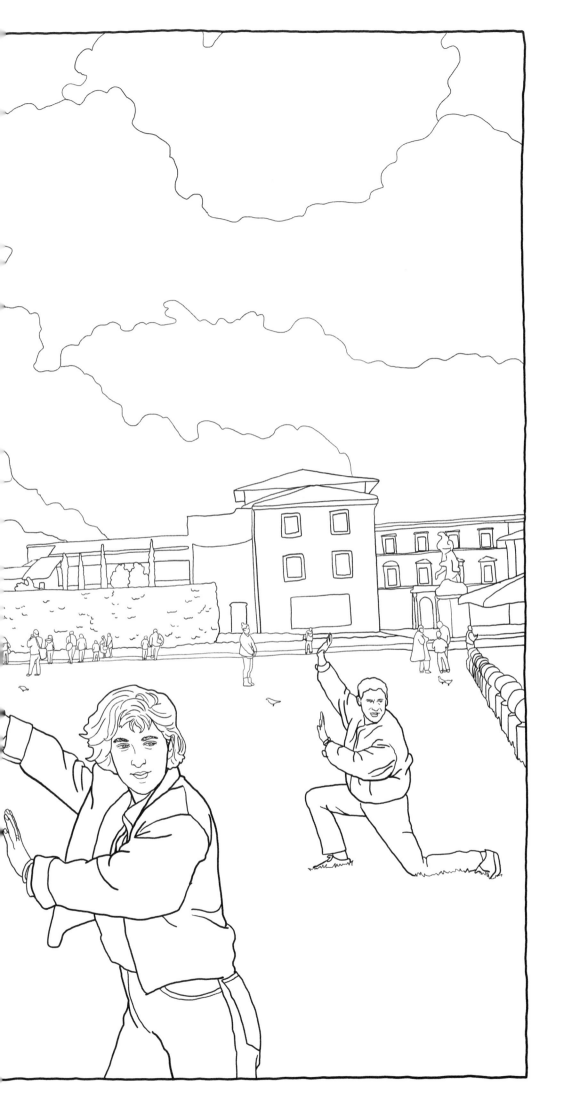

The Leaning Tower of Pisa, Italy, 1990

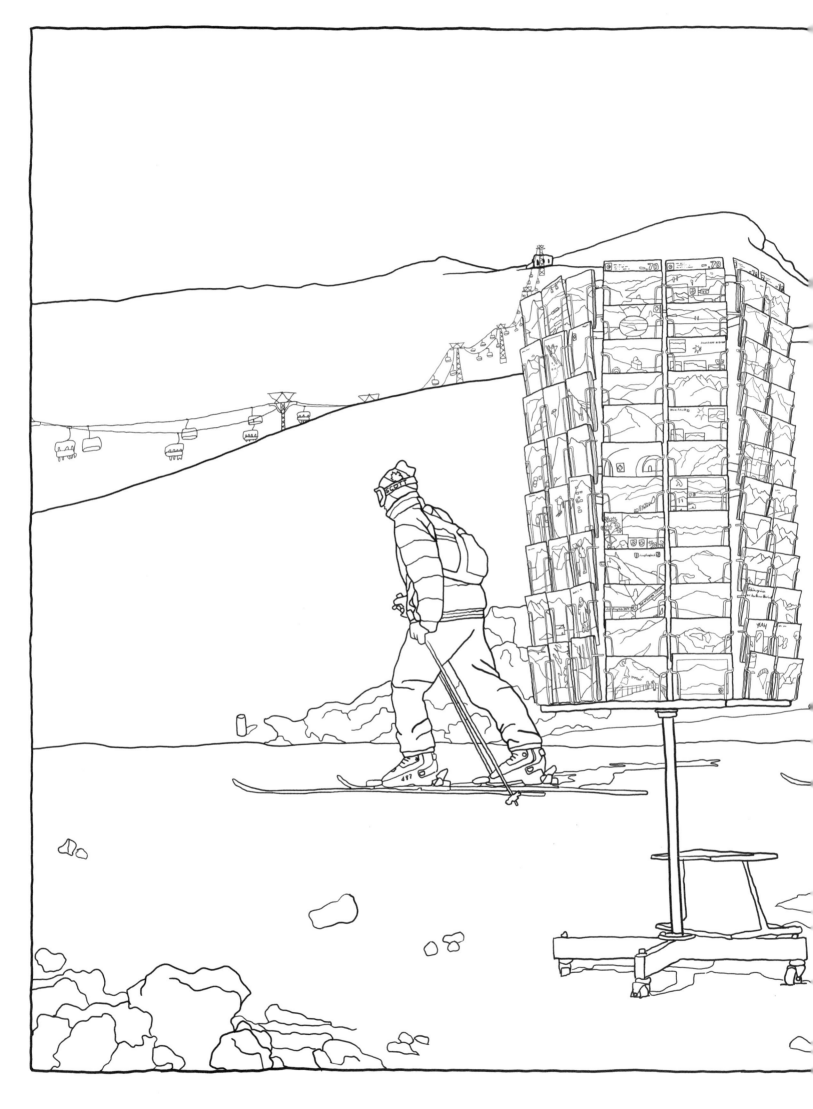

Kleine Scheidegg, Switzerland, 1994

FOLLOWING PAGES: *Tokyo, Japan,* 2000

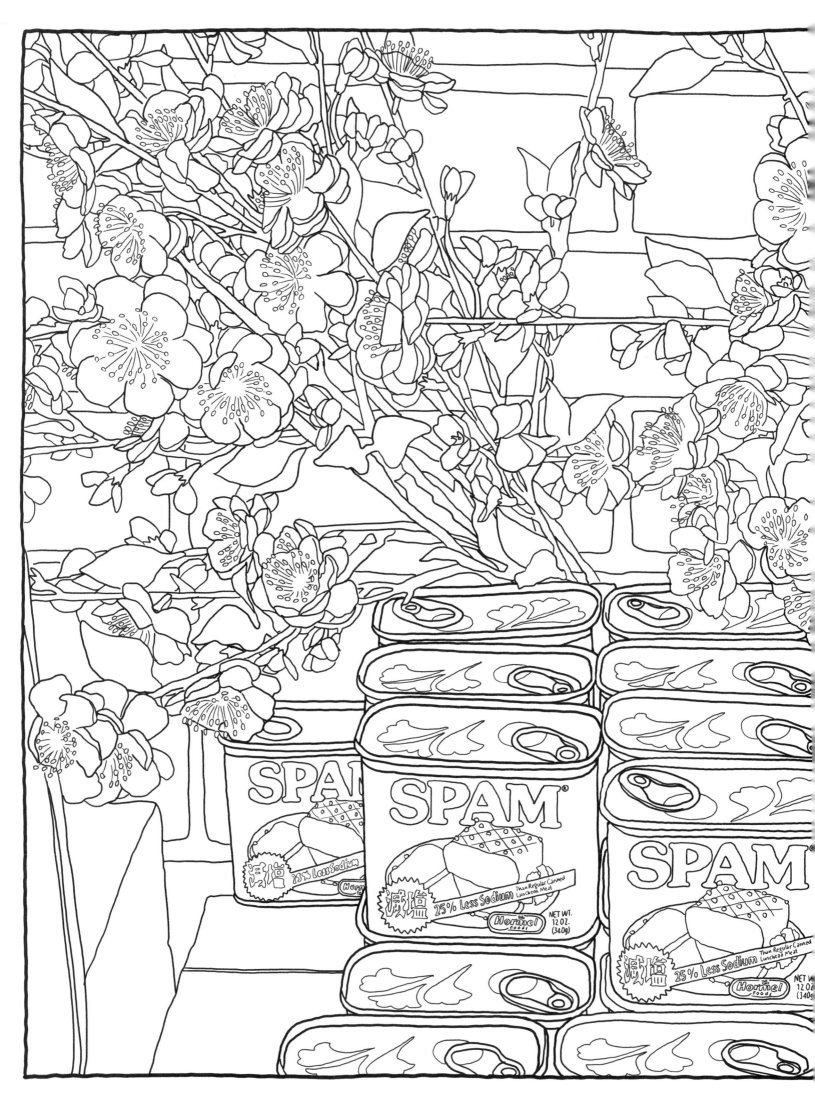

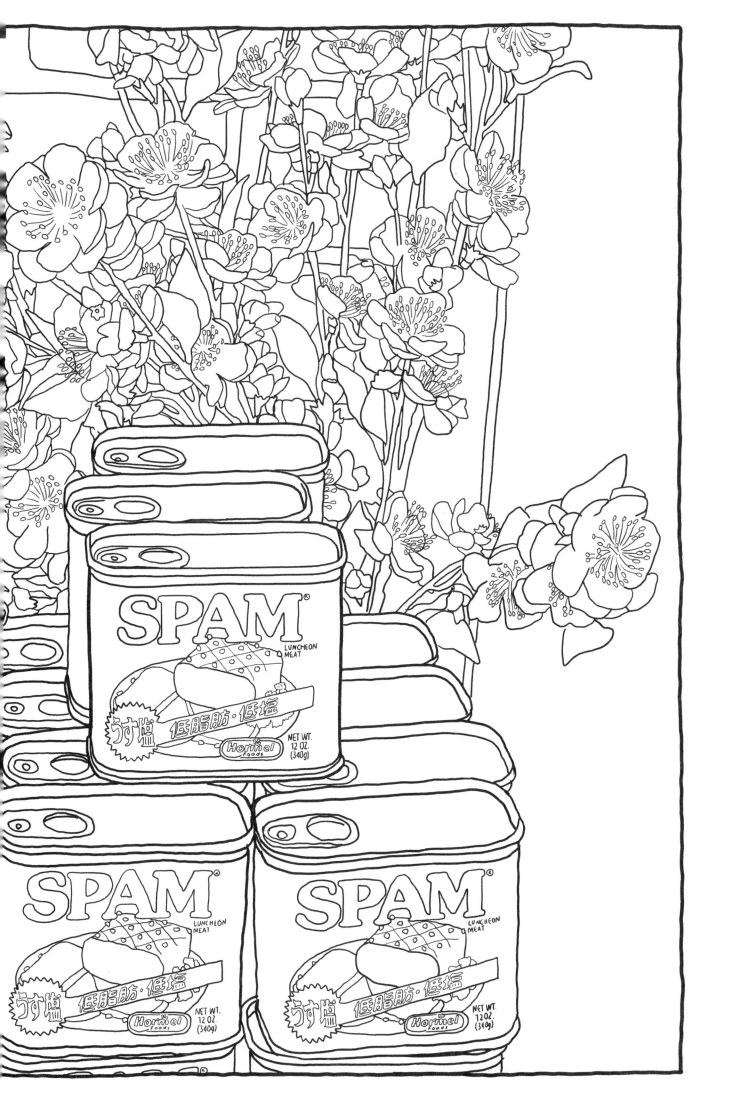

Autoportrait, Amsterdam, Holland, 2000

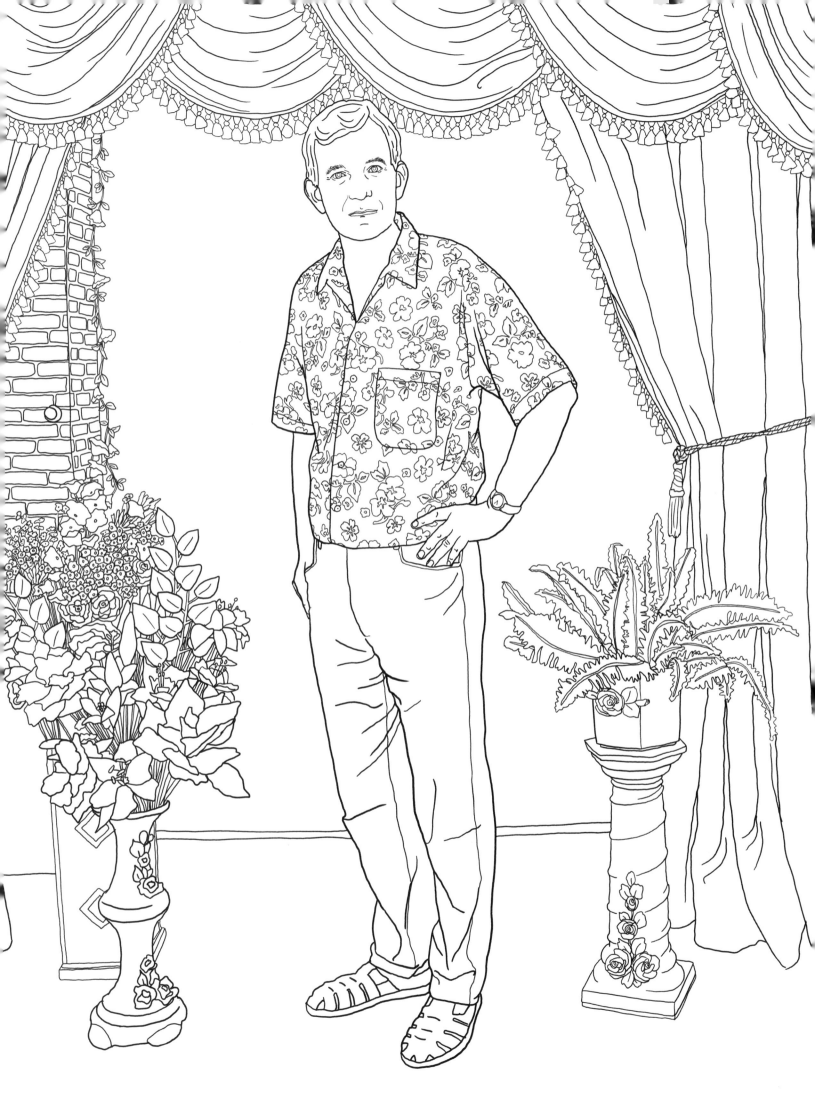

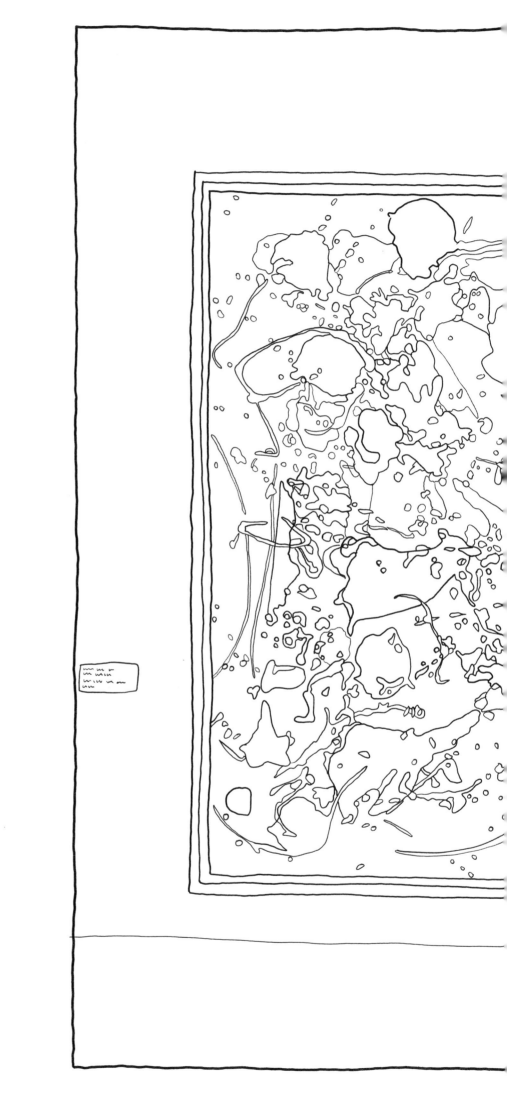

DIFC Gulf Art Fair, Dubai, UAE, 2007

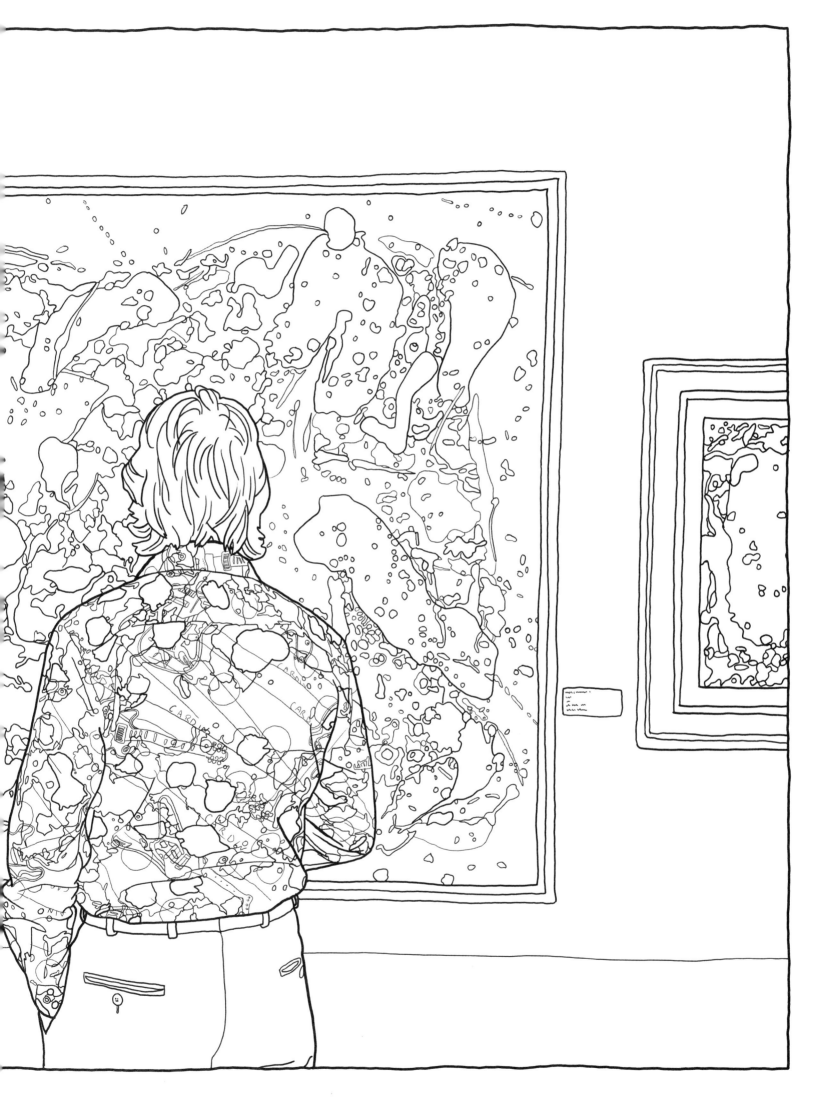

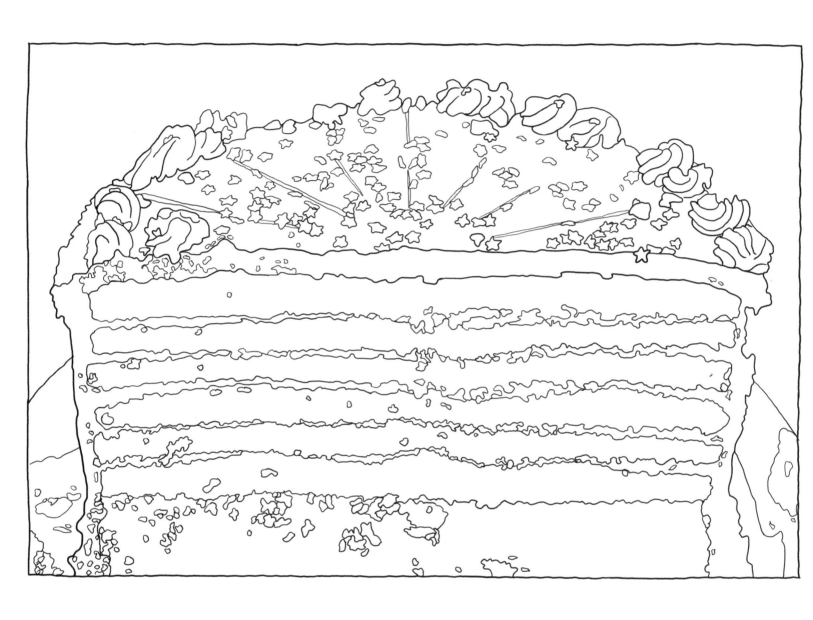

Atlanta, USA, 2010

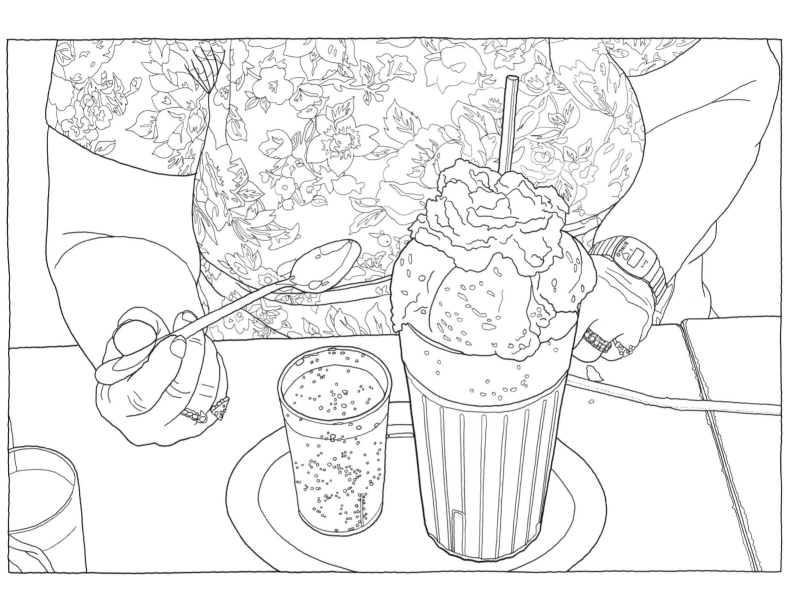

Florida, USA, 1998

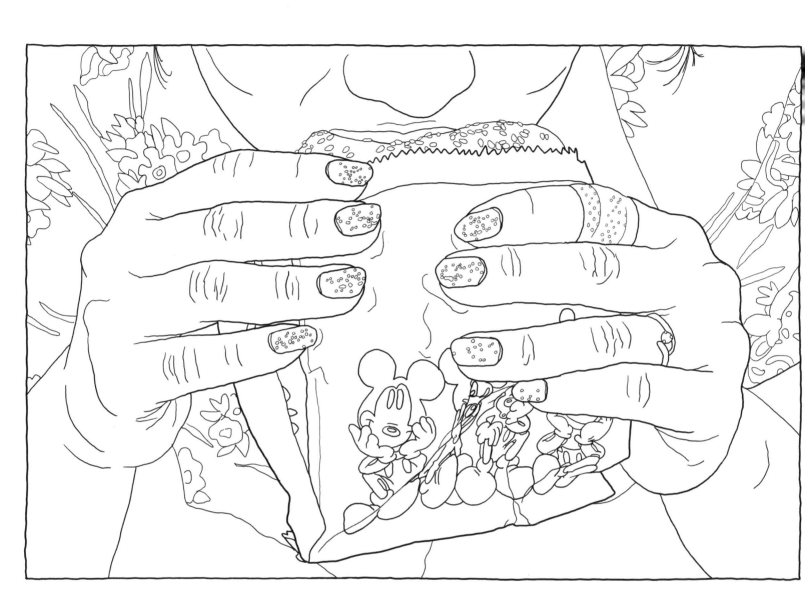

Disneyland, Tokyo, Japan, 1998

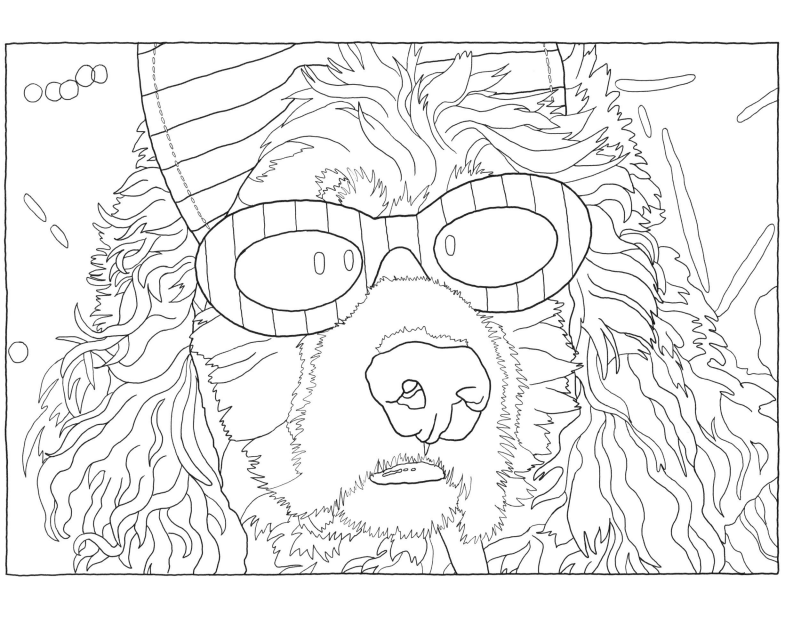

Venice Beach, California, USA, 1998

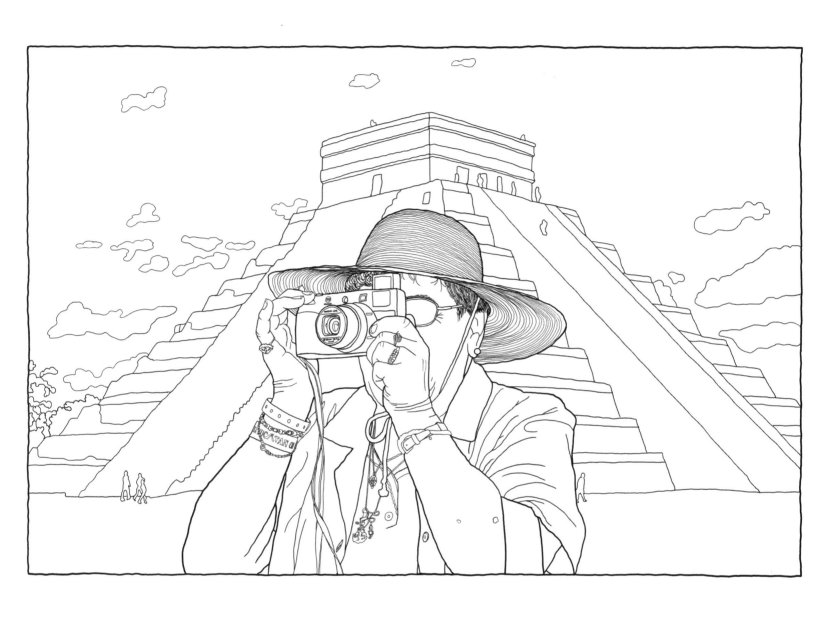

Chichen Itza, Mexico, 2002

RIGHT: *Autoportrait, Havana, Cuba,* 2001

Honister Pass, Lake District, England, 1994

FOLLOWING PAGES: *Ascot, England*, 1999

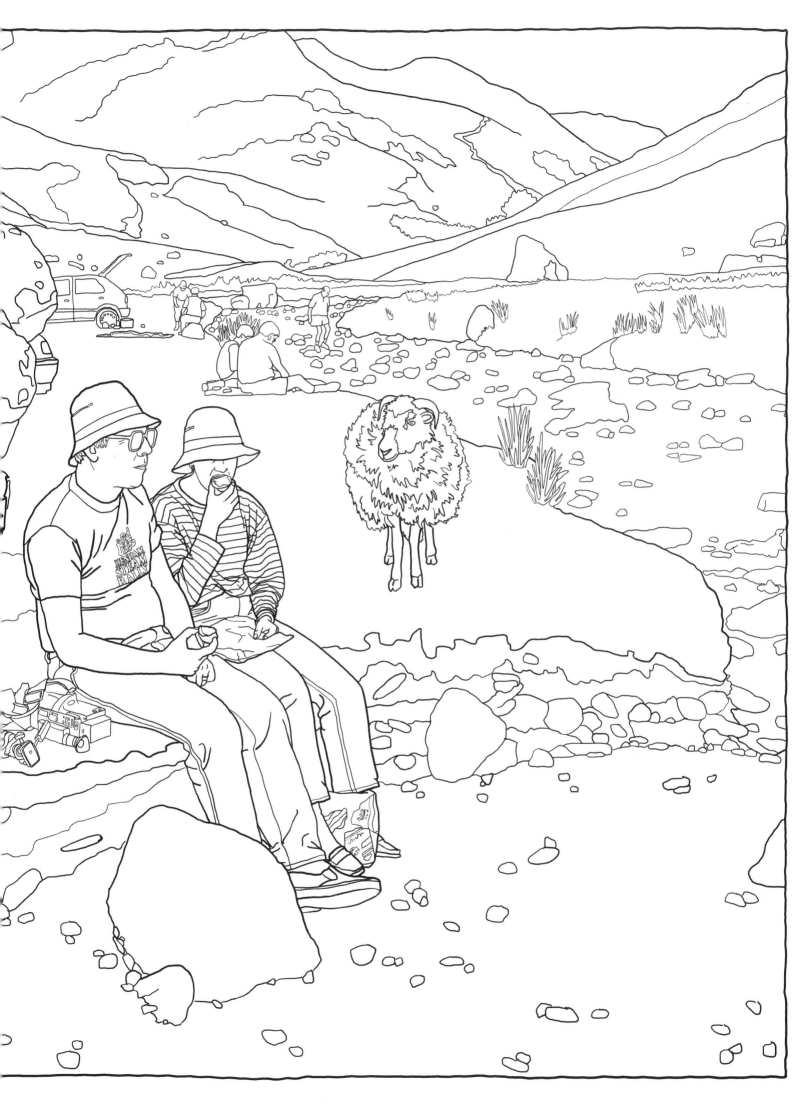

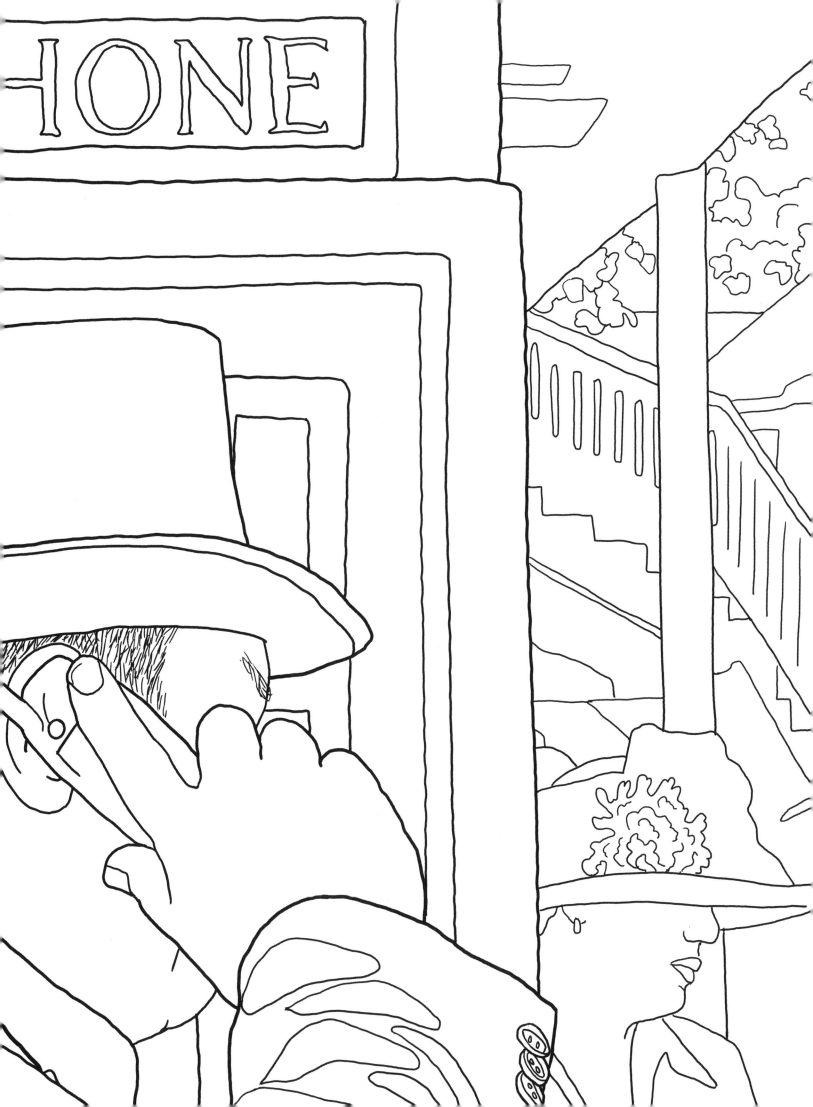

Sedlescombe, England, 1995–99

FOLLOWING PAGES: *Anniversary Tea, Boulderclough Methodist Chapel, Calderdale, England*, 1978

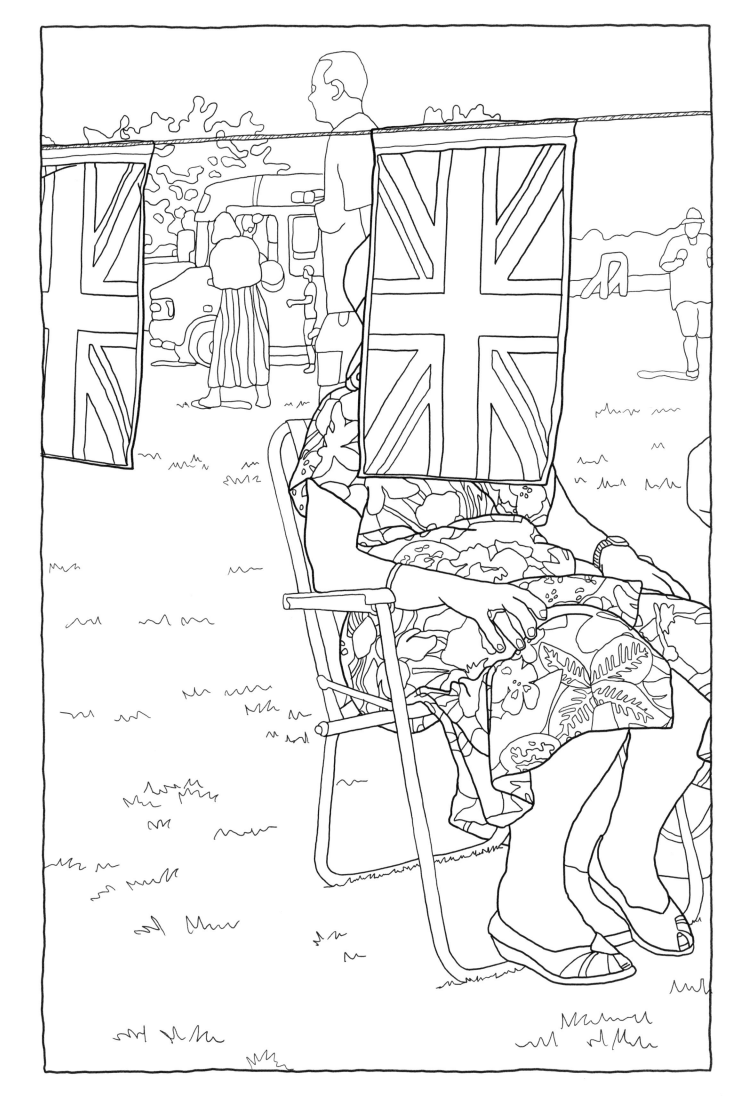

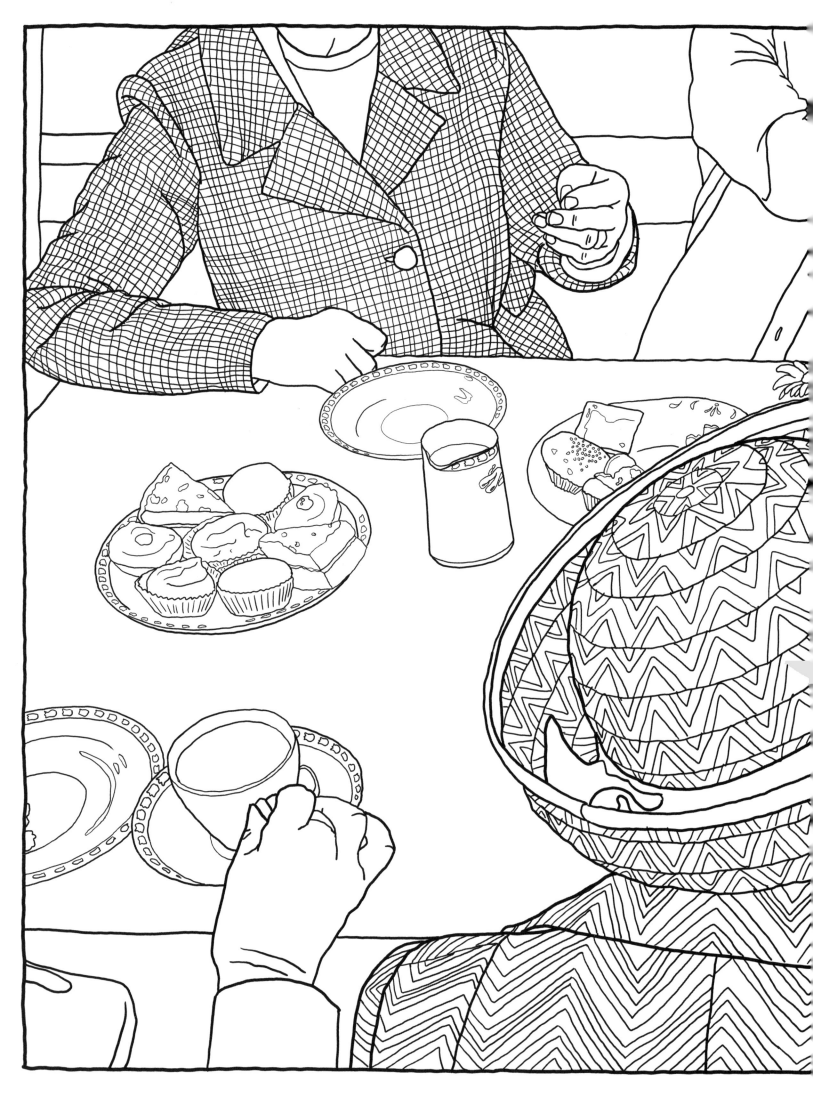

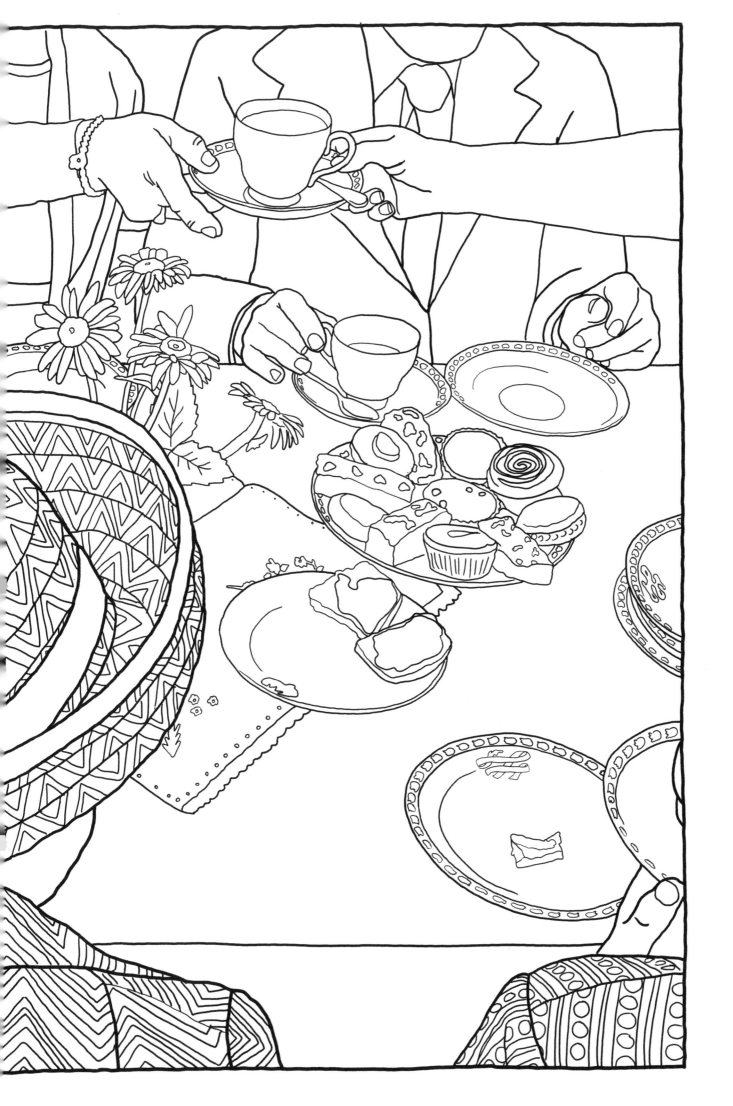

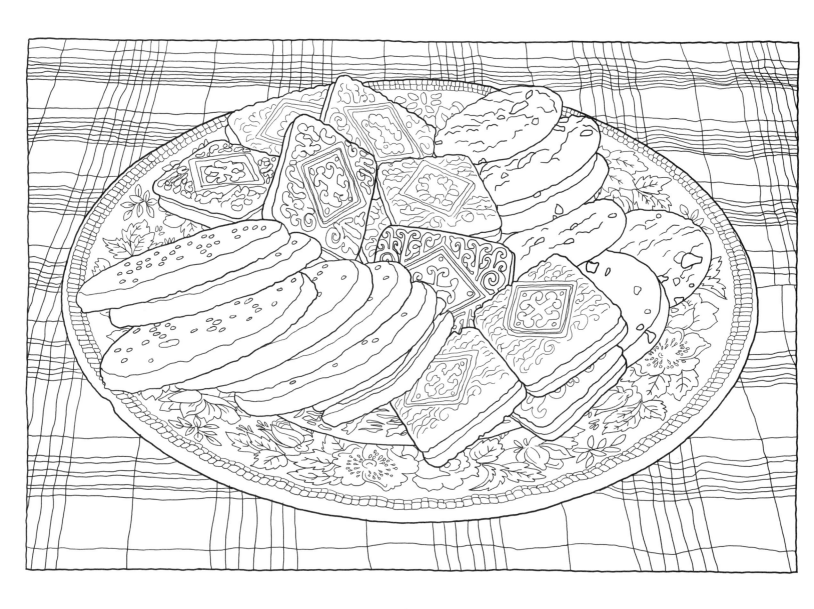

Bridport, England, 2003

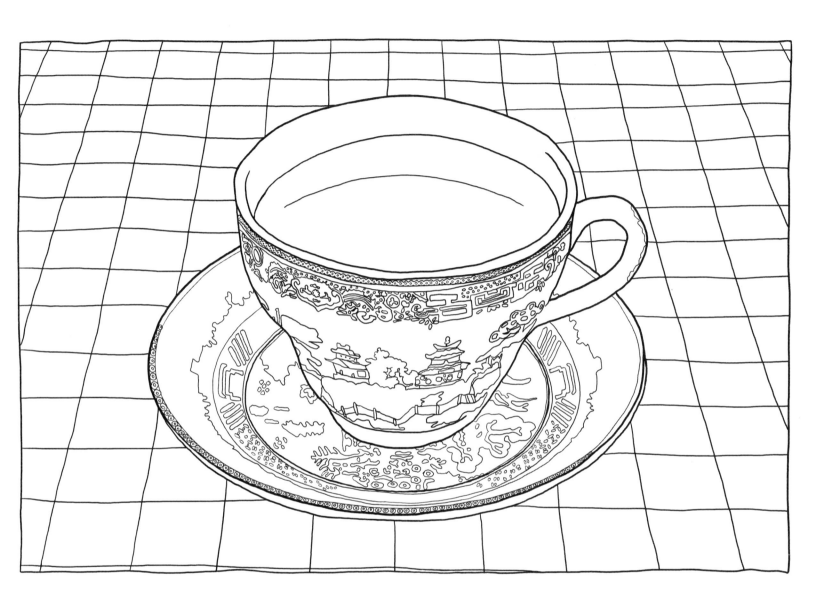

Sand Bay, England, 1997

FOLLOWING PAGES: *Mayor of Todmorden's Inaugural Banquet, Todmorden, England, 1977*

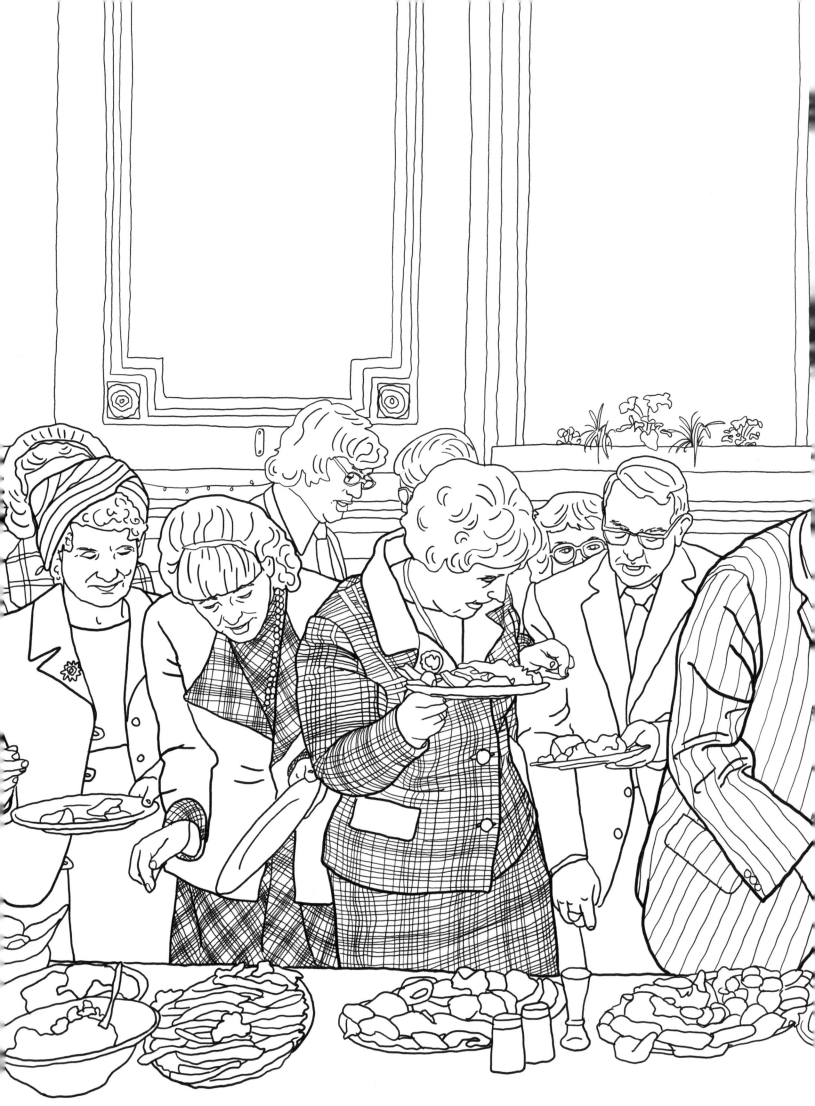

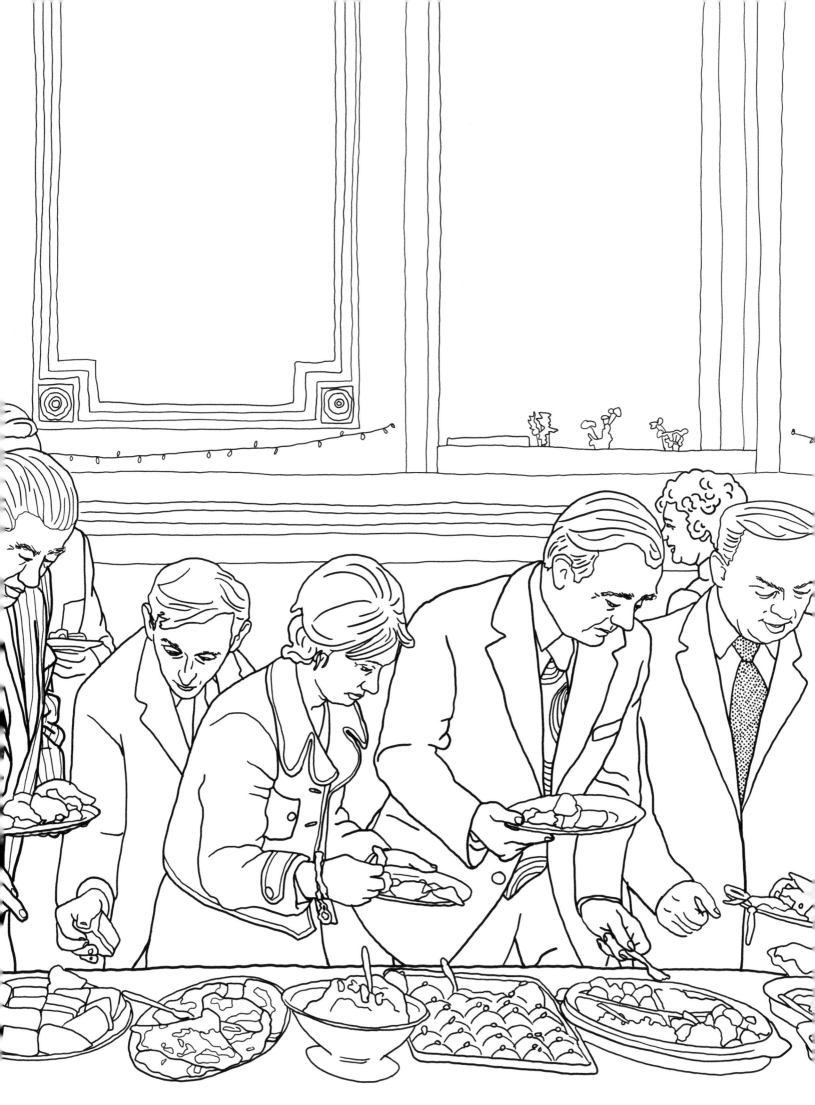

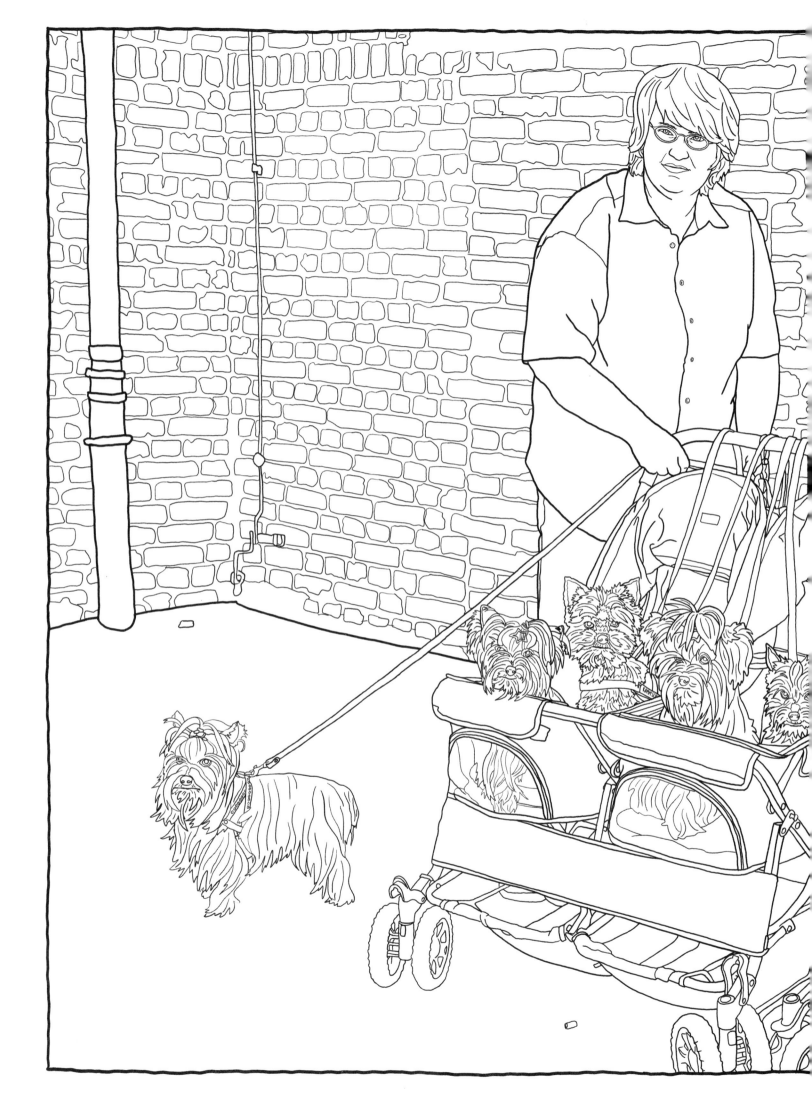

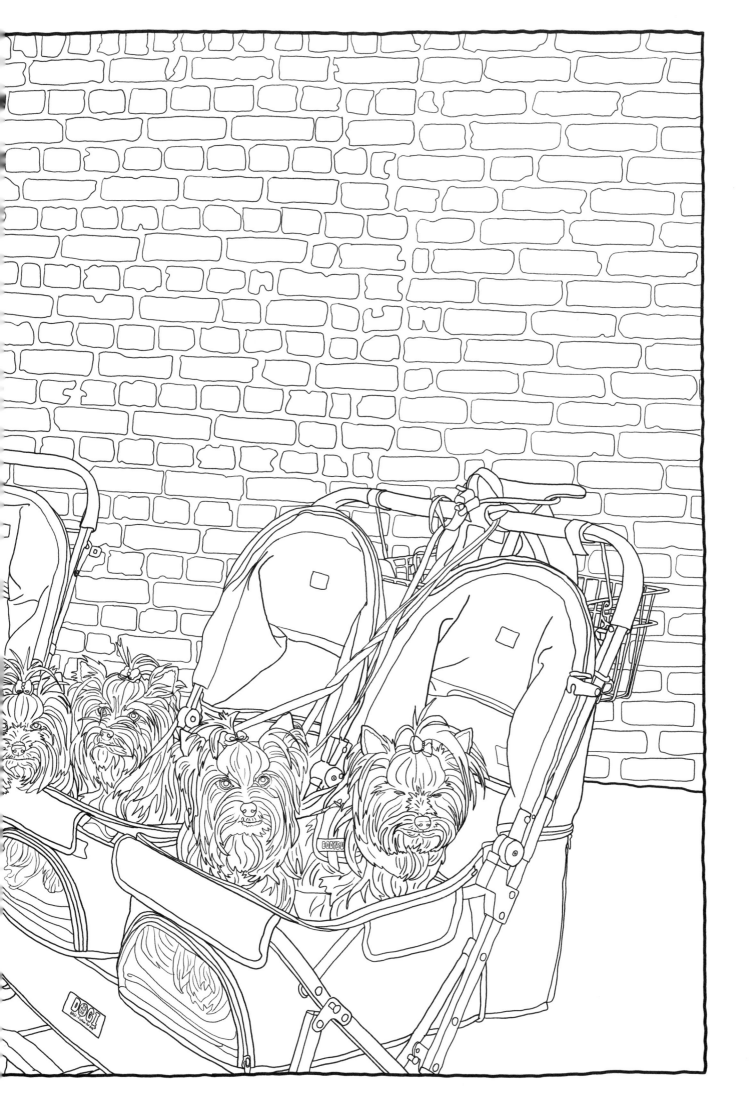

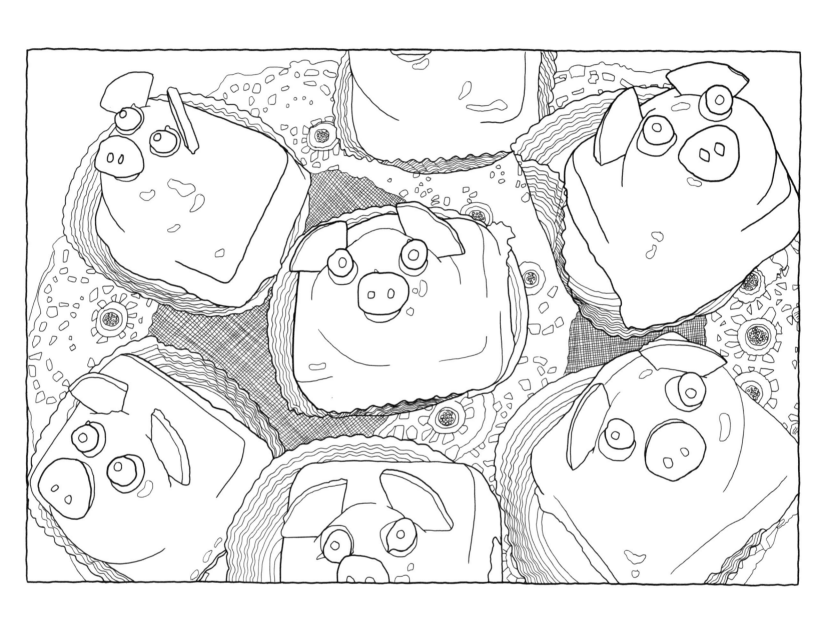

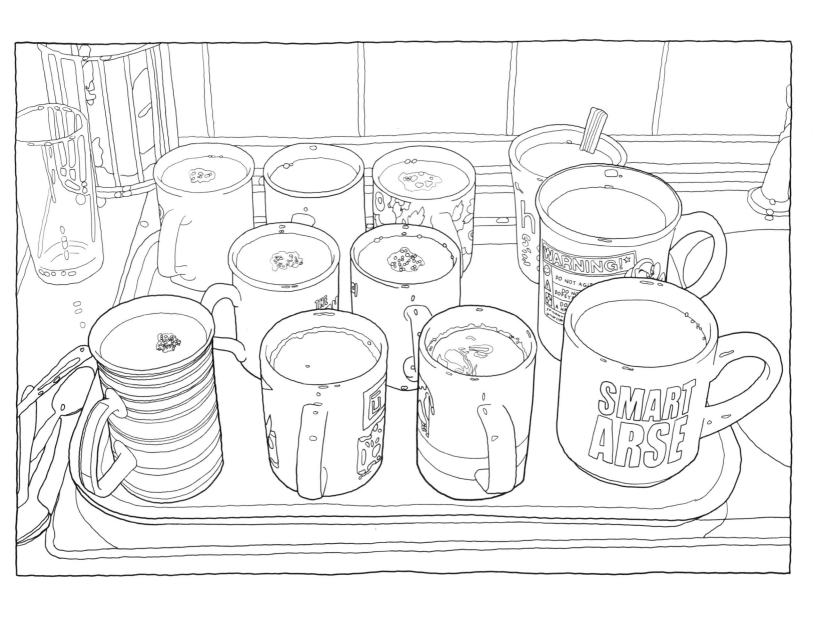

Walsall, England, 2011

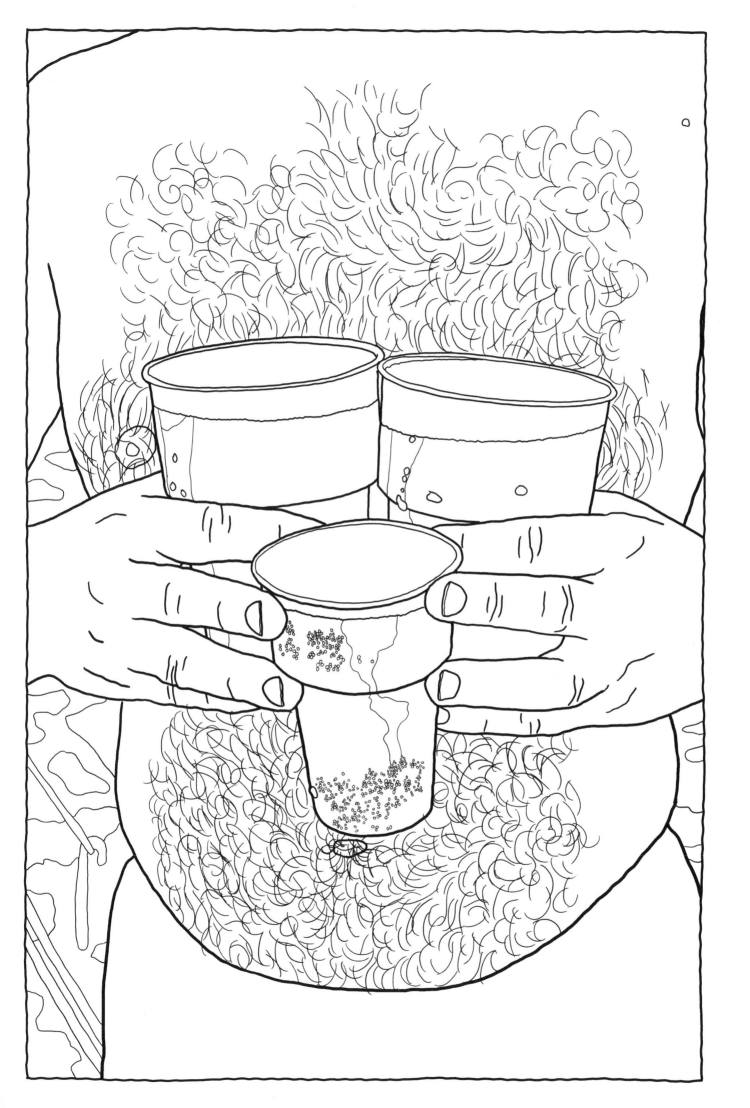

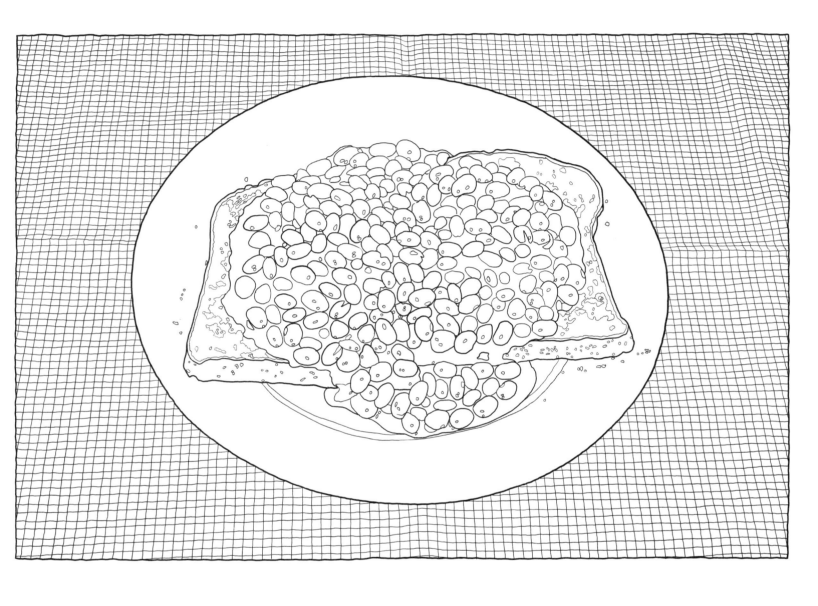

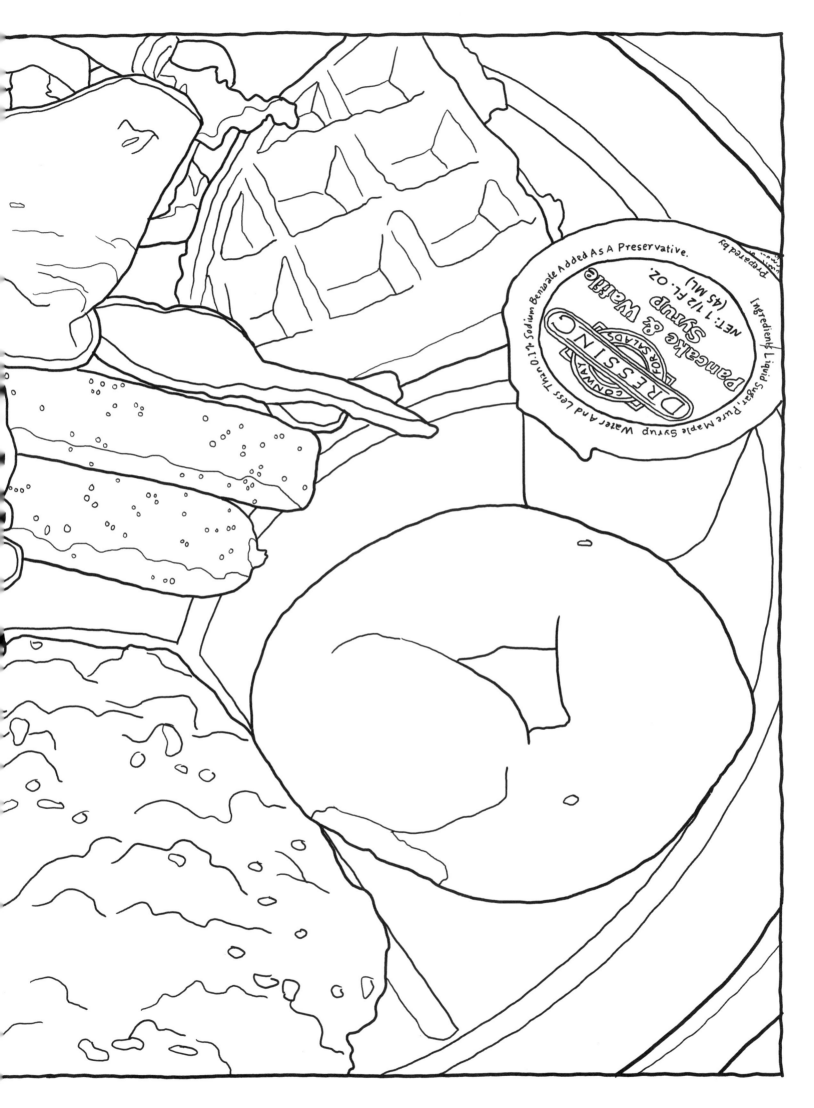

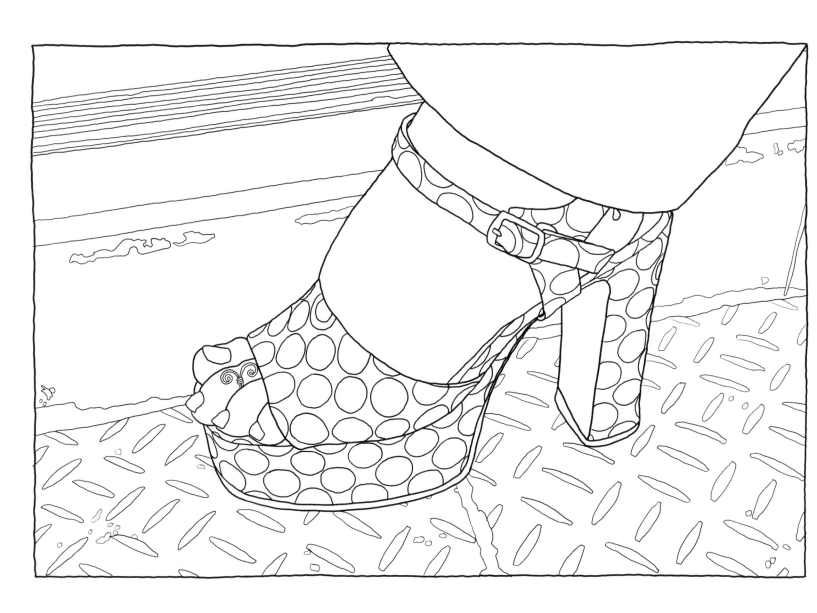

Tokyo, Japan, 1998

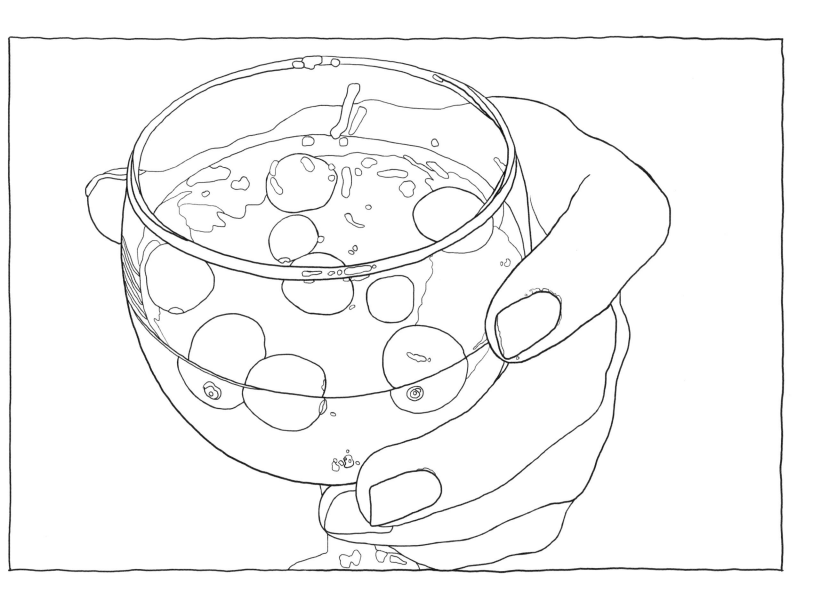

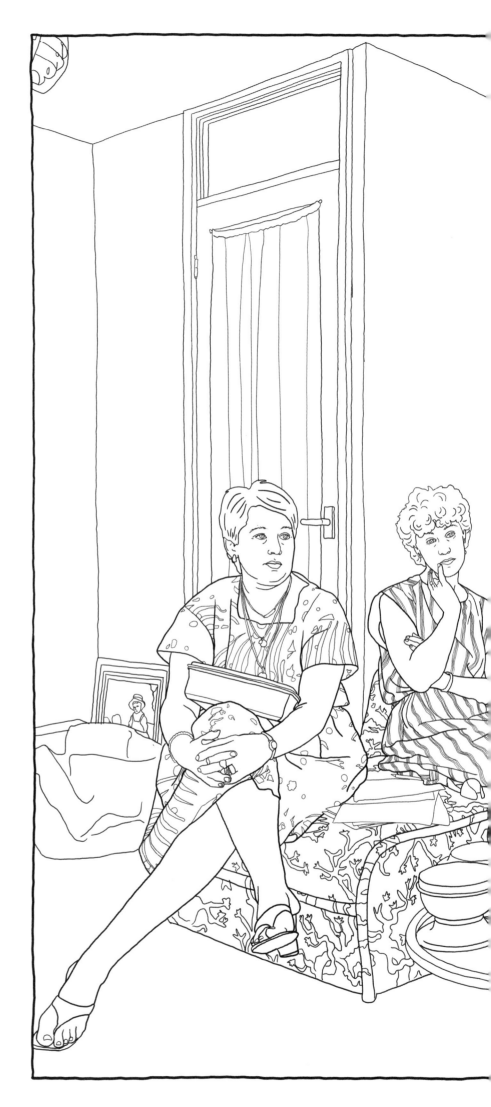

A Tupperware Party, Salford, England, 1986

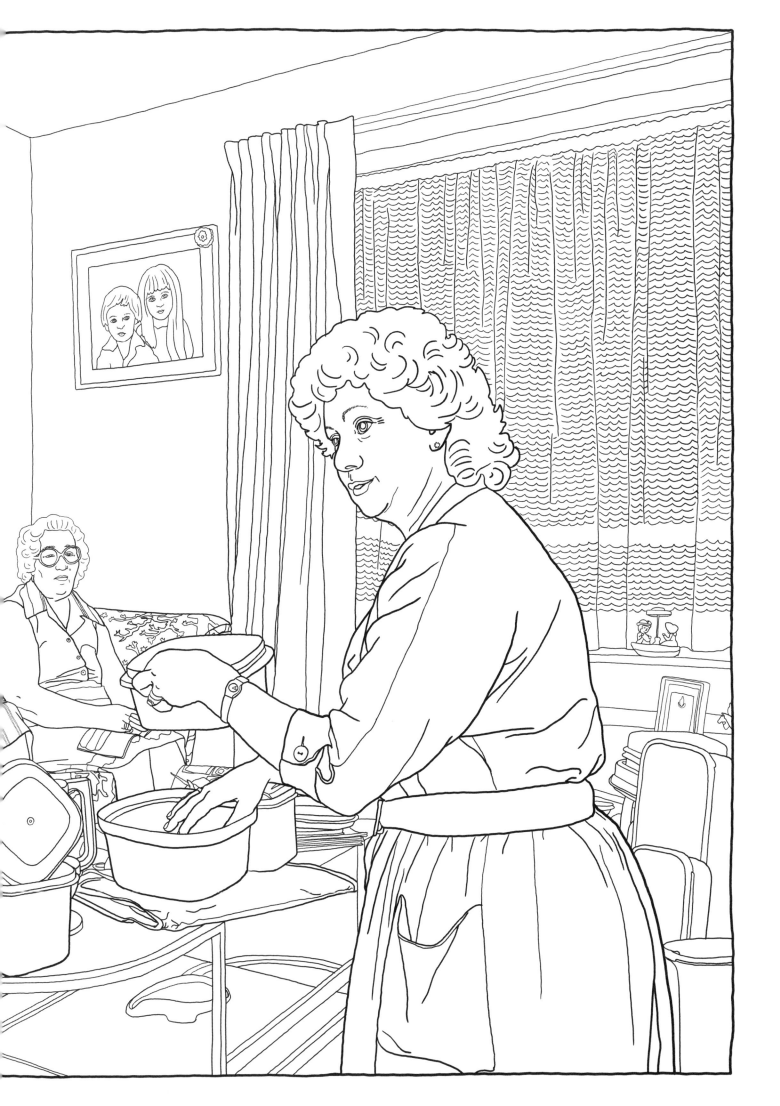

England, 1991

FOLLOWING PAGES: *Malvern, England*, 2000

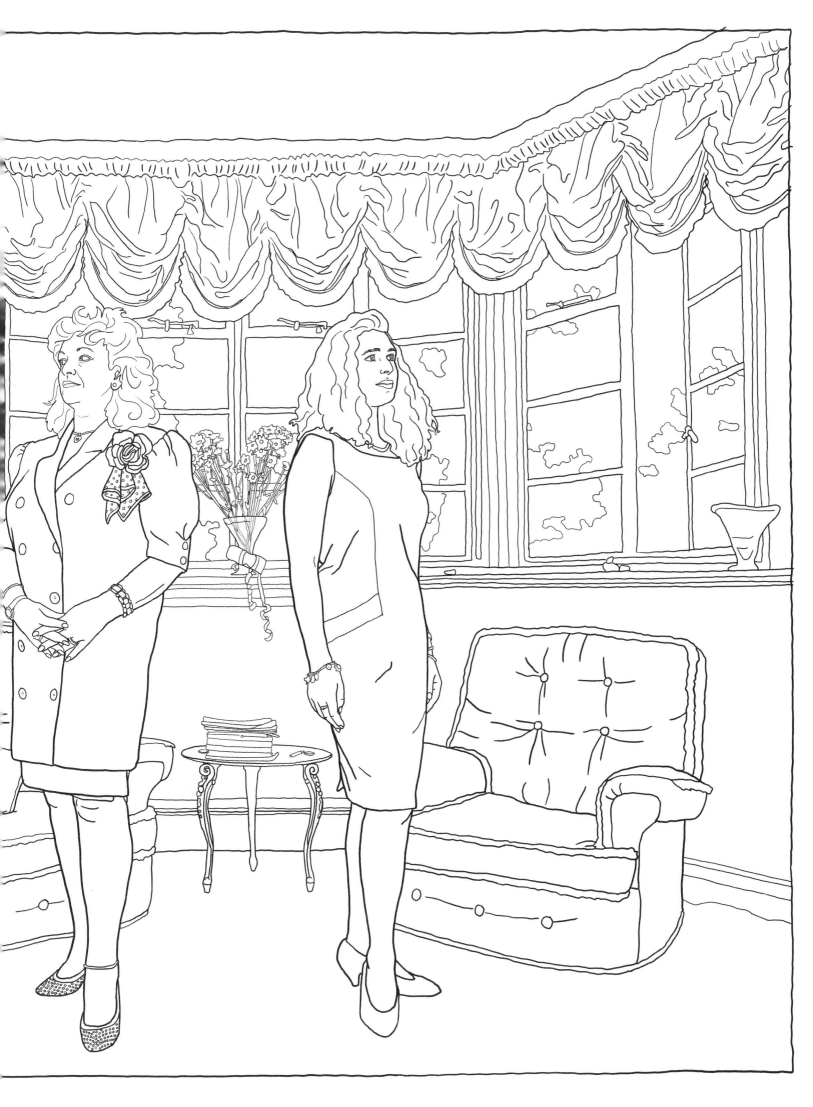

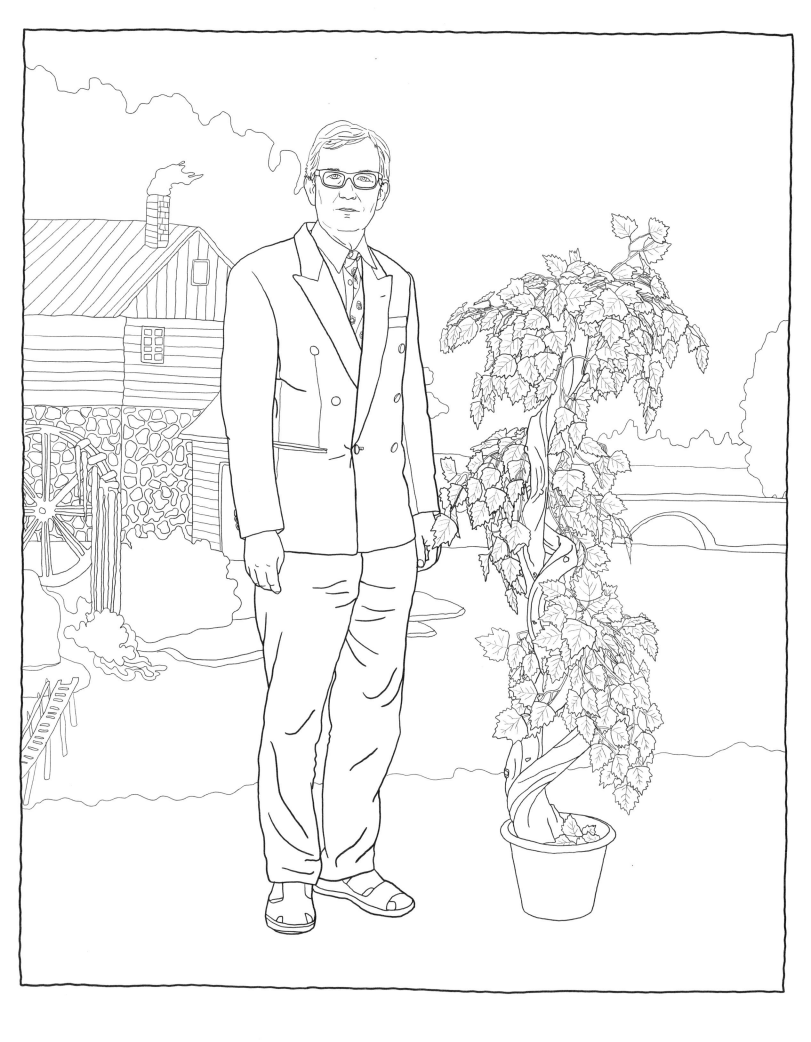

Autoportrait, Singapore, 2007

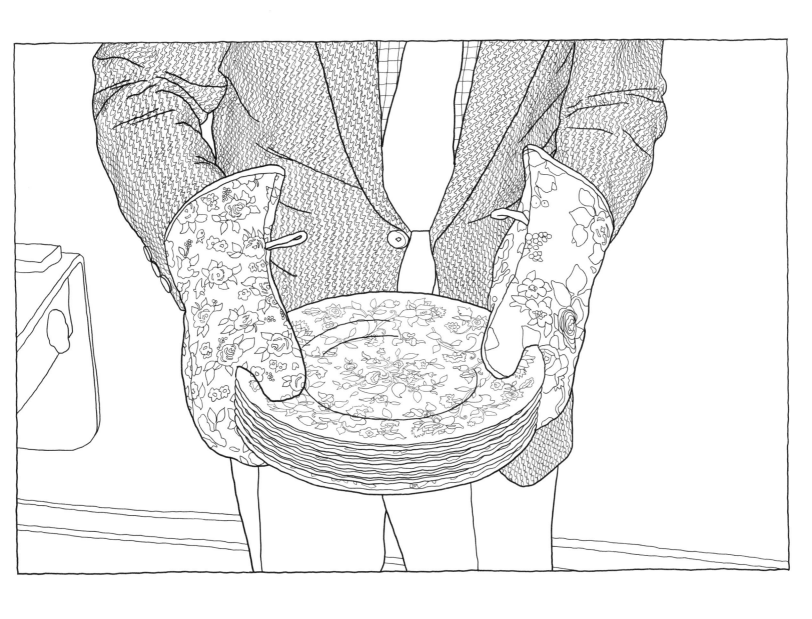

Christmas Dinner, Horncastle, England, 1998

England, 1994

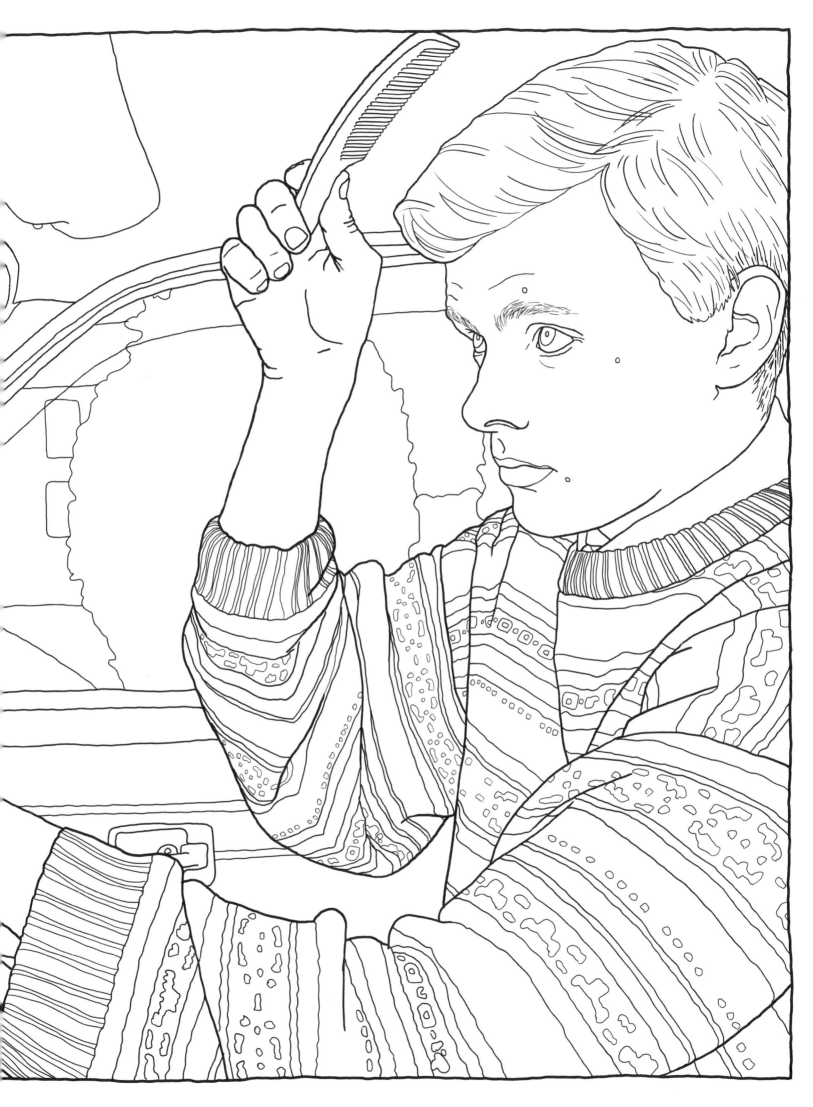

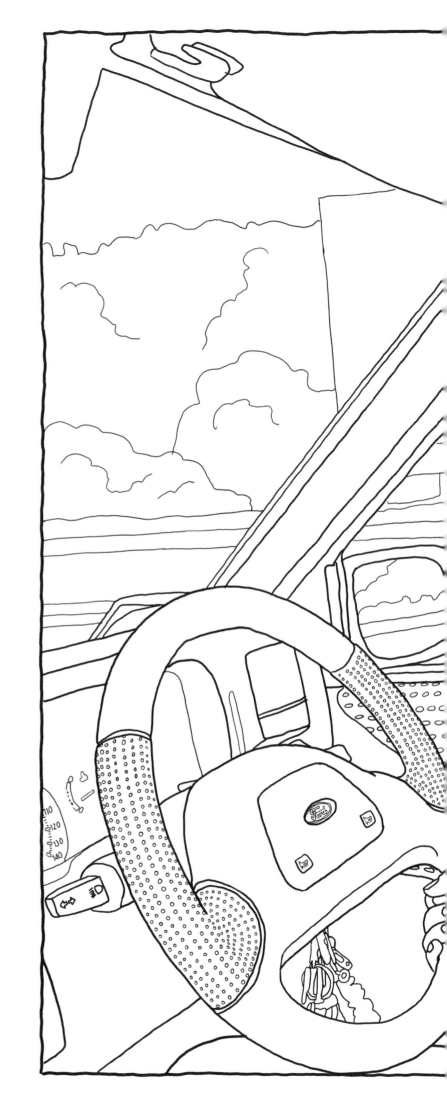

England, 1994

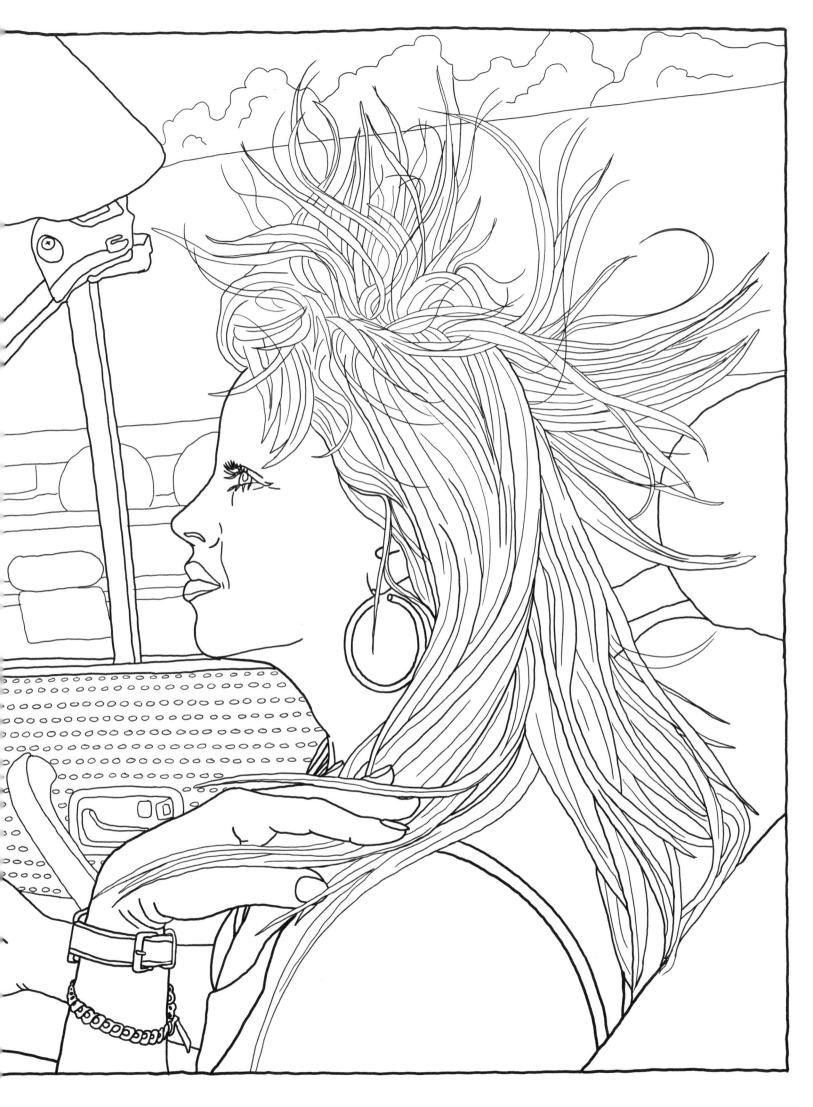

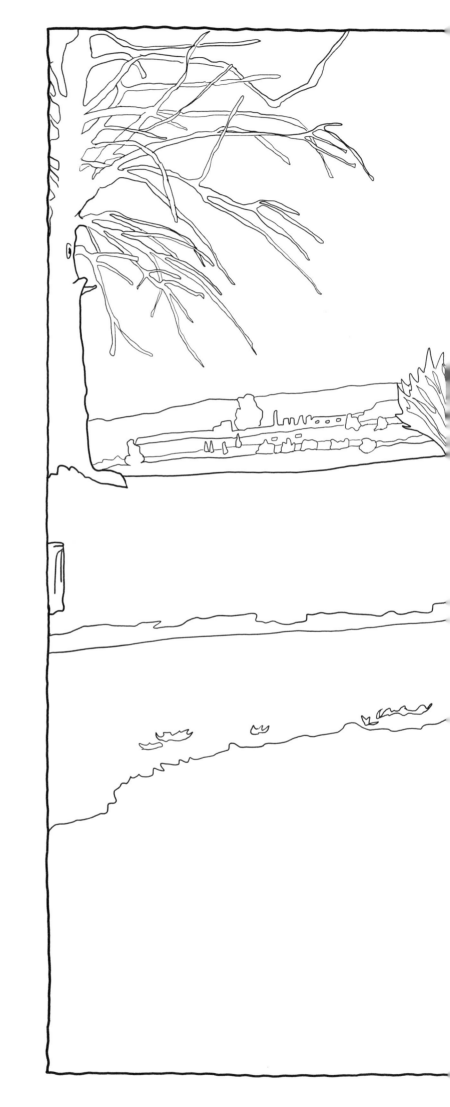

Newport, Wales, 1988

FOLLOWING PAGES: *Punta del Este, Uruguay*, 2006

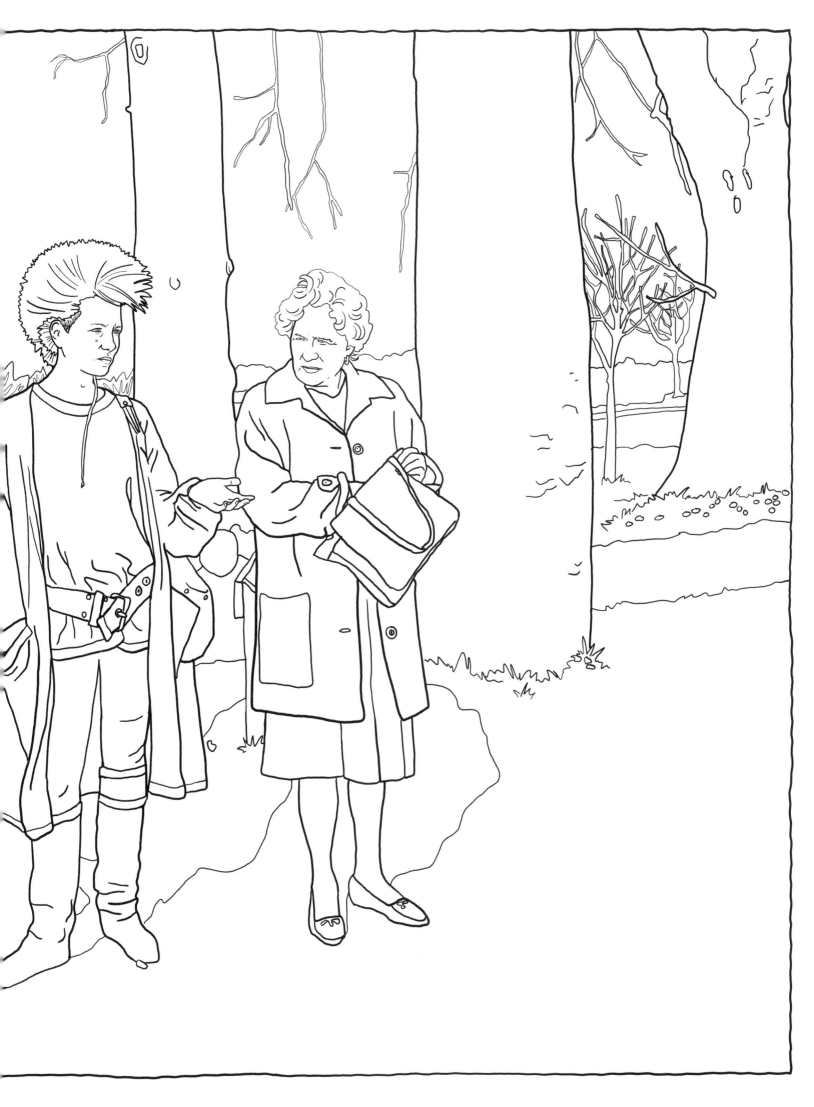

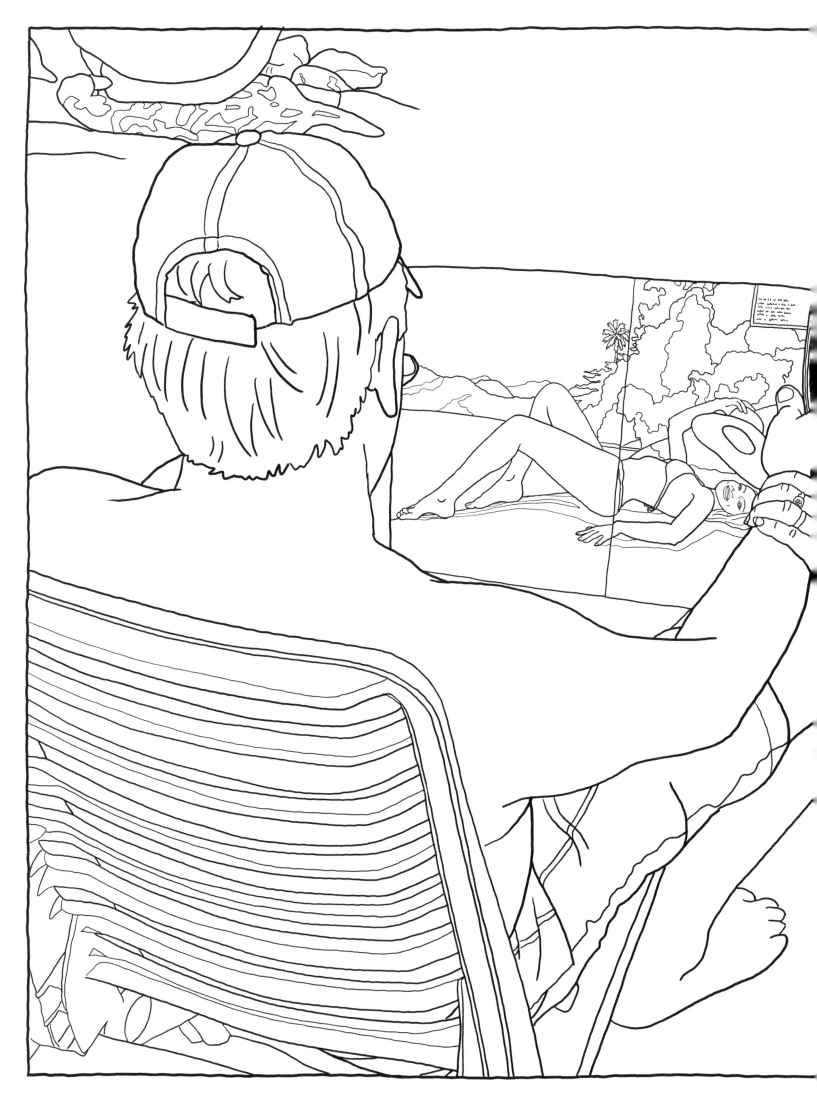

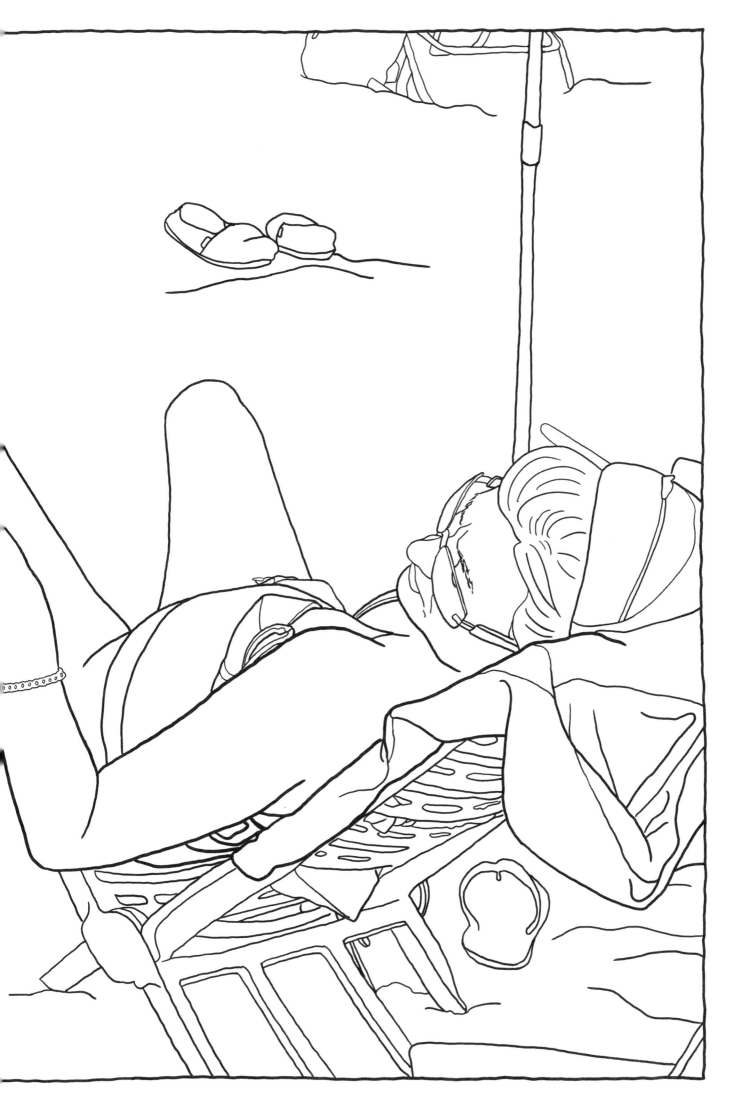

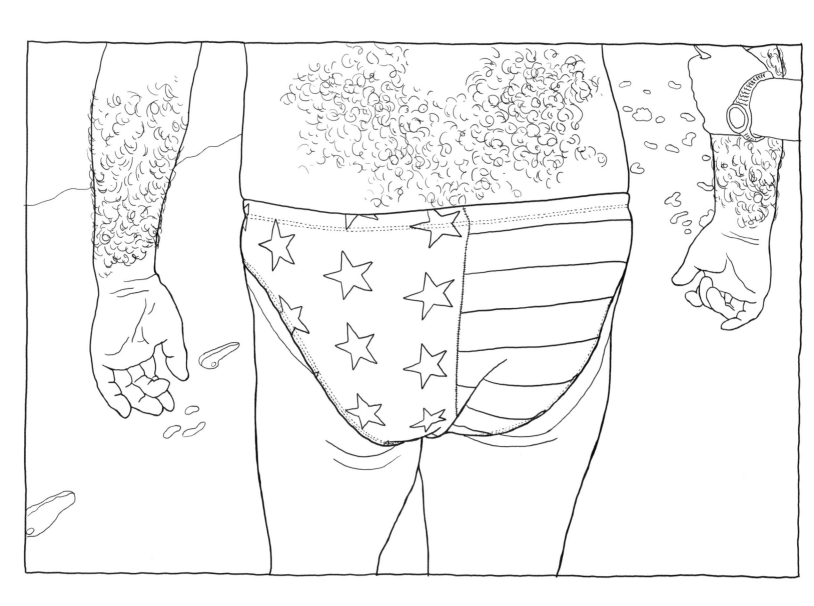

Miami, Florida, USA, 1998

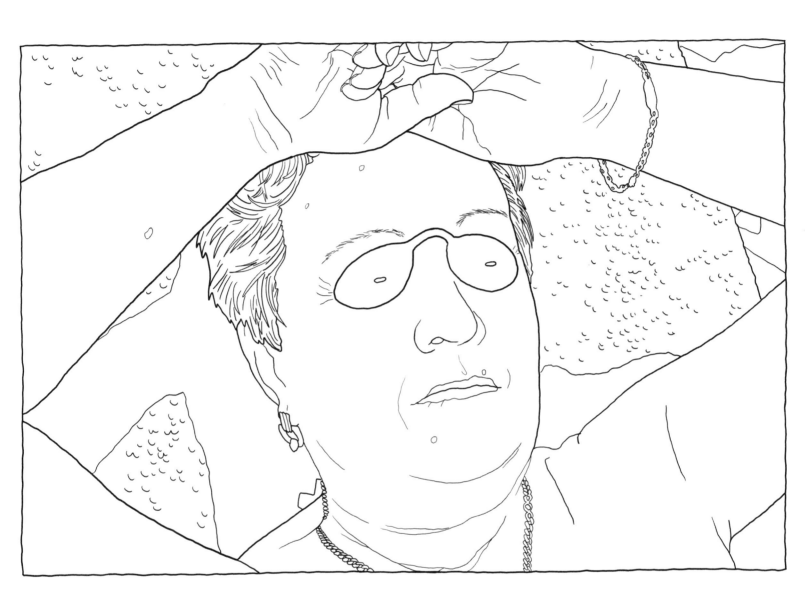

Benidorm, Spain, 1997

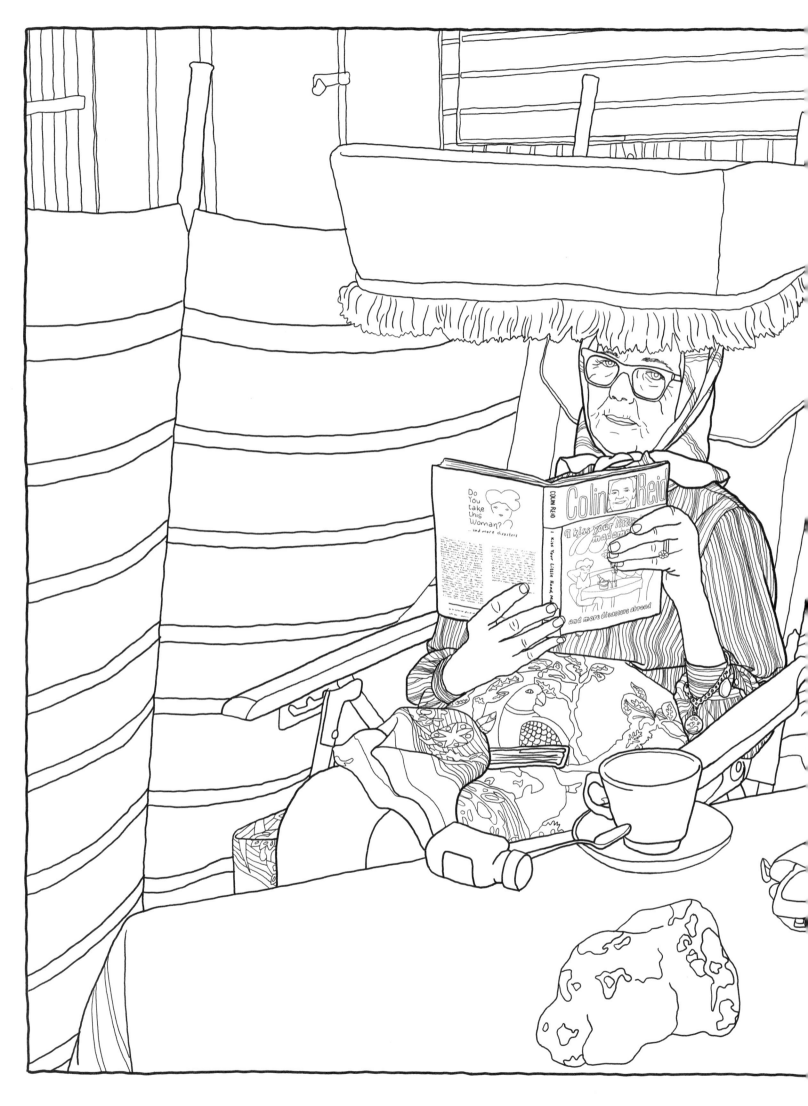

Margate, England, 1986

FOLLOWING PAGES: *Sorrento, Italy*, 2014

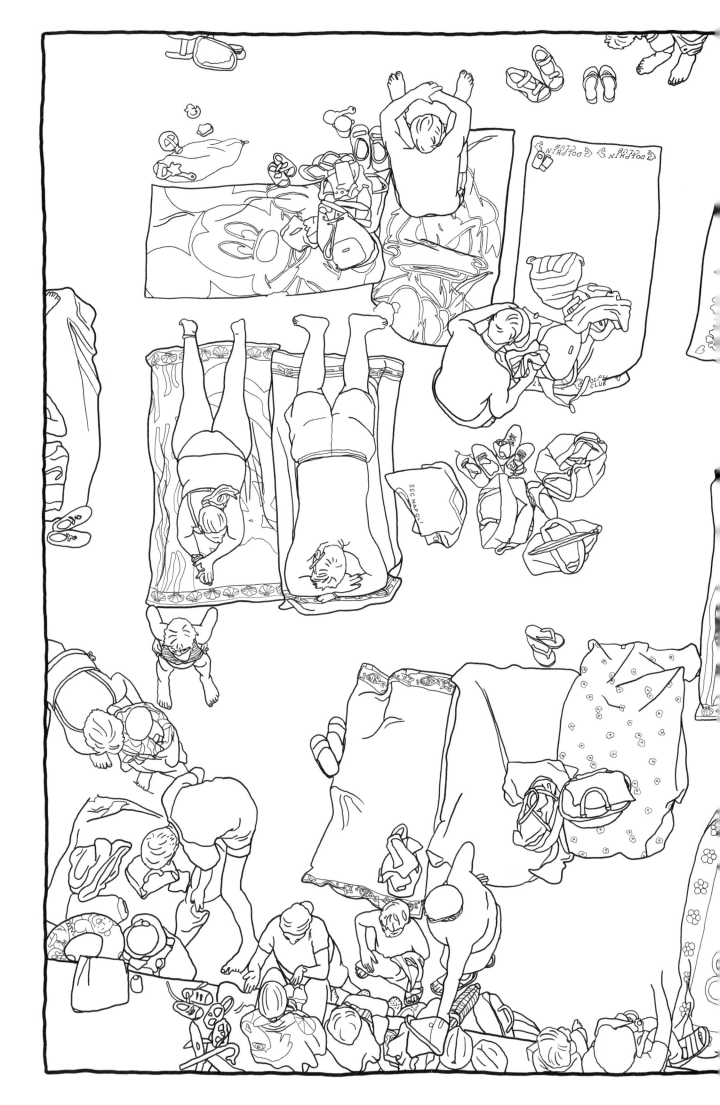

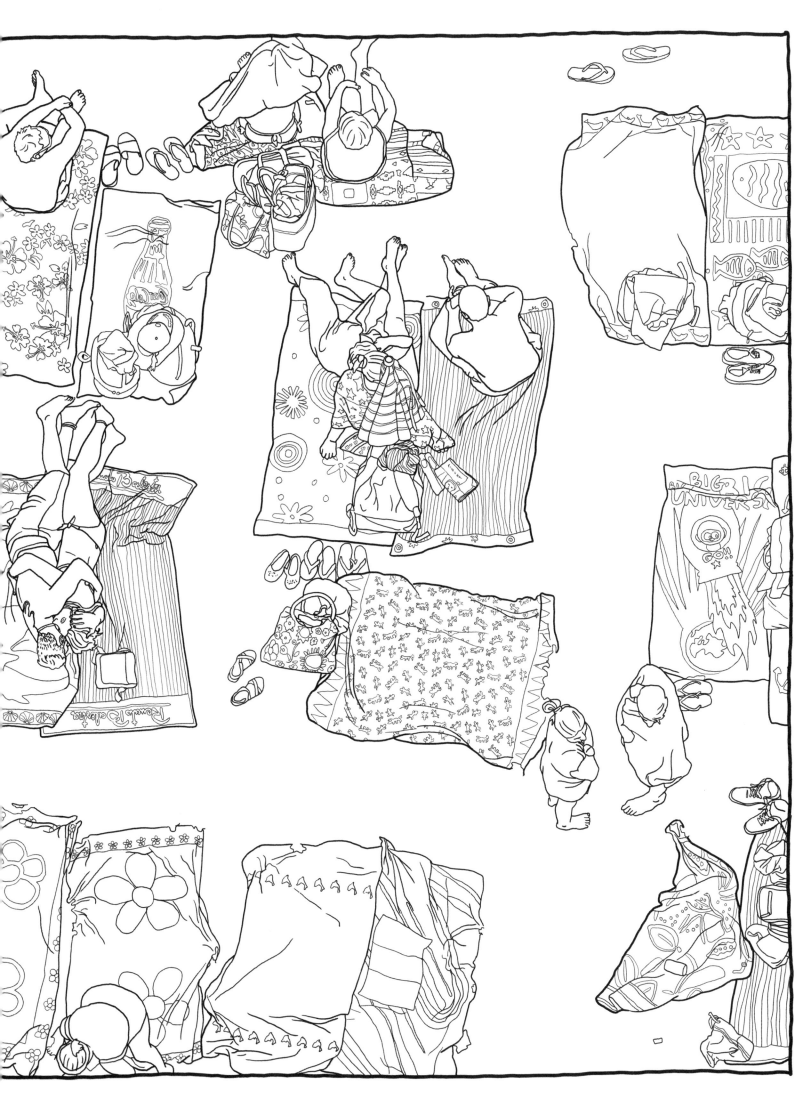

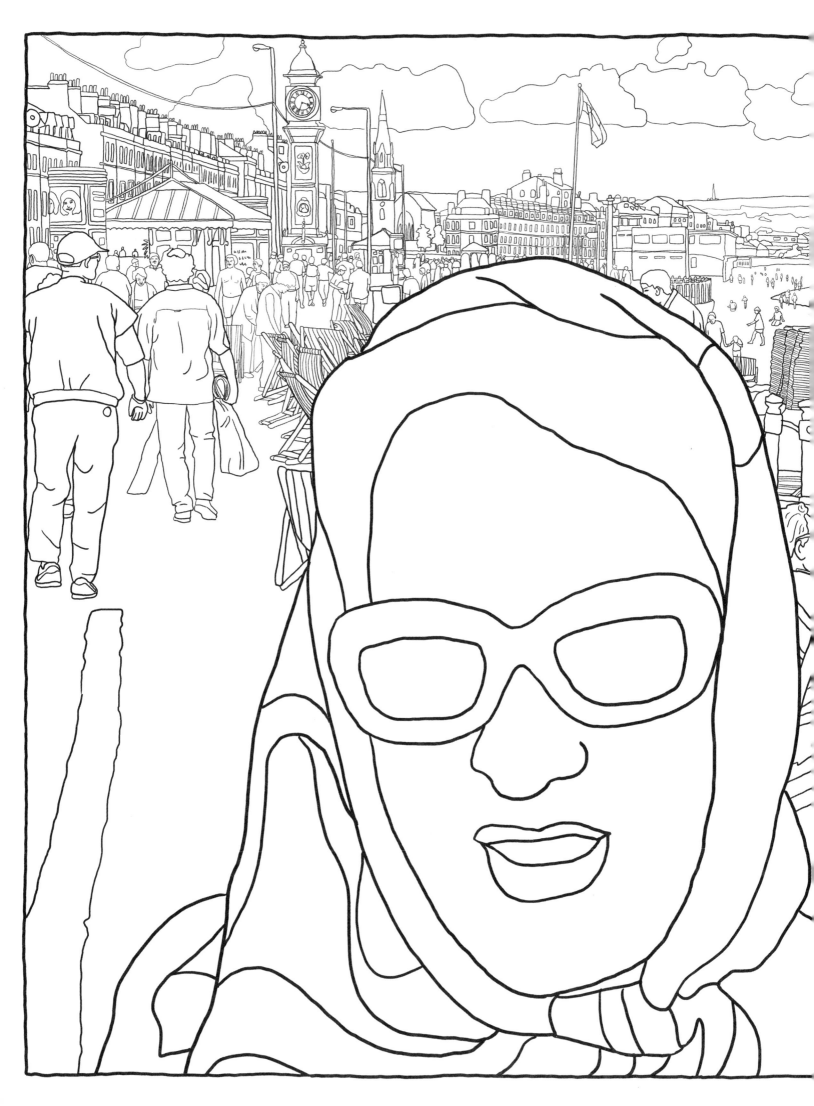

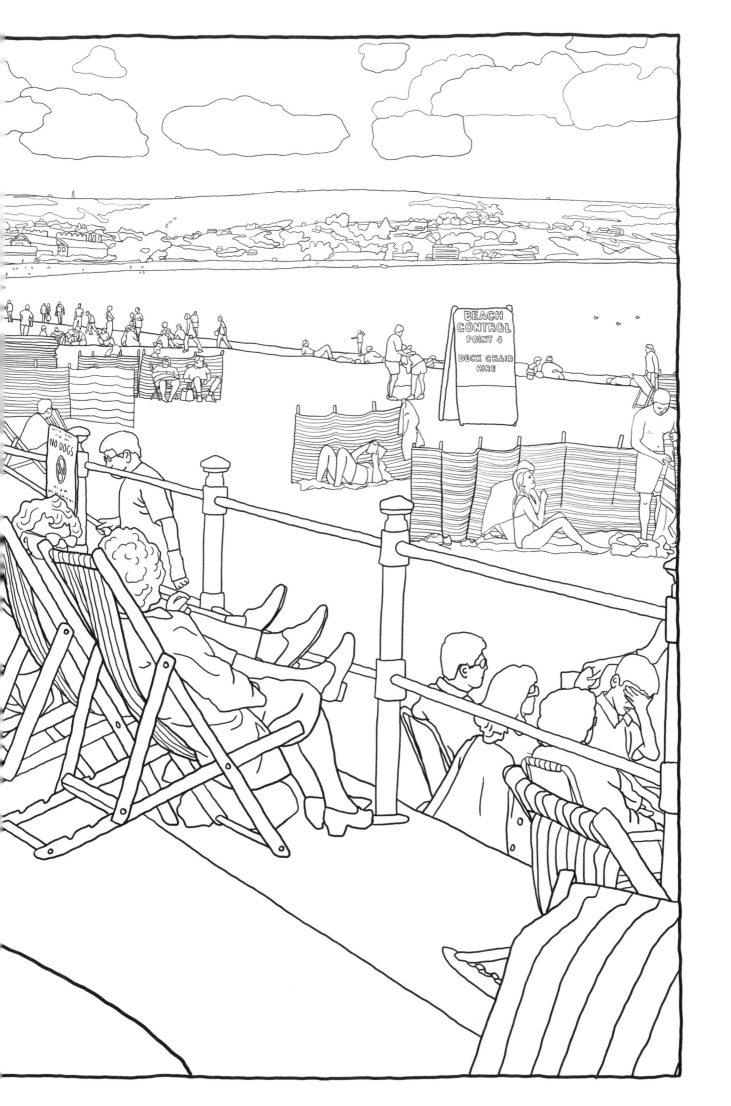

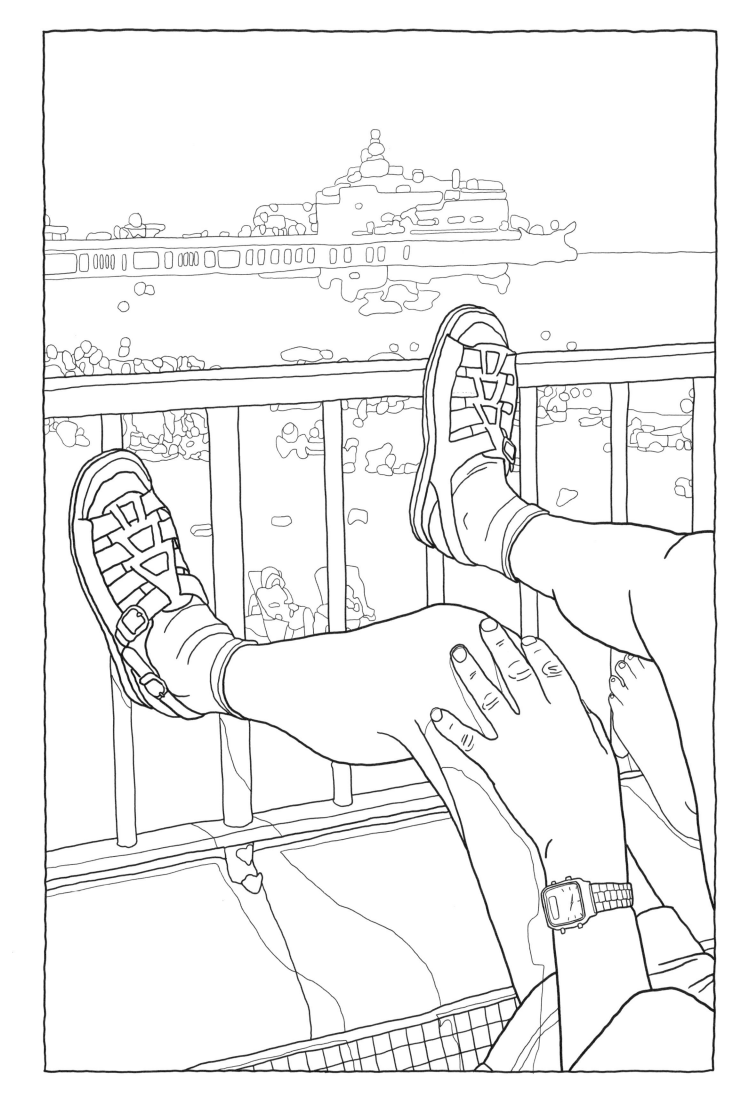

The Martin Parr Coloring Book!
Photographs by Martin Parr
Drawings by Jane Mount
Cover lettering by Nate Utesch

FRONT COVER: *Autoportrait, Benidorm, Spain,* 1997; BACK COVER:
DIFC Gulf Art Fair, Dubai, UAE, 2007; FRONT FLAP: *Sedlescombe,
England,* 1995–99; FRONT INSIDE FLAP: *Sorrento, Italy,* 2014; BACK
FLAP: *Autoportrait, Havana, Cuba,* 2001; BACK INSIDE FLAP:
Tokyo, Japan, 2000

Editor: Denise Wolff
Designer: Emily Lessard
Production Manager: Nelson Chan
Associate Editor: Sally Knapp
Senior Text Editor: Susan Ciccotti
Work Scholars: Charlotte Chudy and Lucas Vasilko

Additional staff of the Aperture book program includes:
Chris Boot, Executive Director; Lesley A. Martin, Creative Director;
Amelia Lang, Executive Managing Editor; Kellie McLaughlin, Director
of Sales and Marketing; Richard Gregg, Sales Director, Books; Samantha
Marlow, Associate Editor; Taia Kwinter, Associate Managing Editor

First edition, 2017
Printed in China
10 9 8 7 6 5 4 3 2 1

ISBN 978-1-59711-425-7

To order Aperture books, contact:
+1 212.946.7154
orders@aperture.org

For information about Aperture trade distribution worldwide, visit:
aperture.org/distribution

aperture
Aperture Foundation
547 West 27th Street, 4th Floor
New York, N.Y. 10001
aperture.org

Aperture, a not-for-profit foundation, connects the photo community
and its audiences with the most inspiring work, the sharpest ideas, and with
each other—in print, in person, and online.

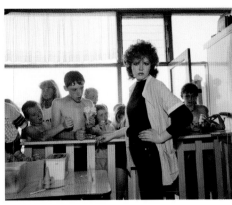
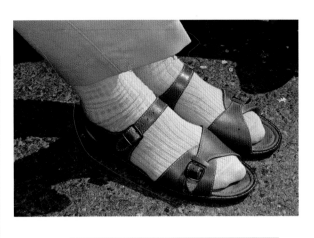
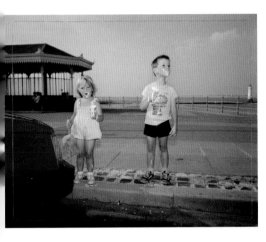

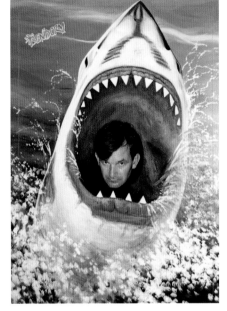
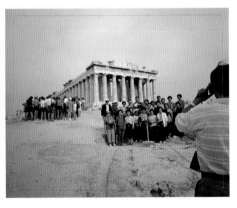
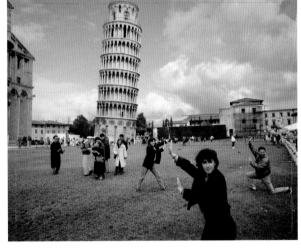
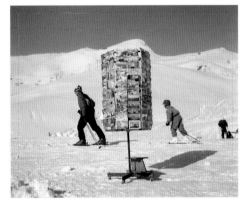
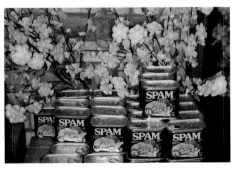
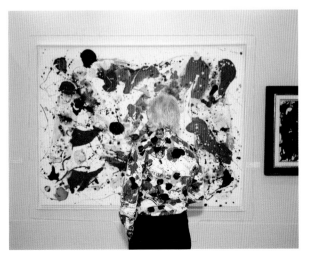
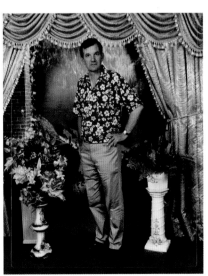

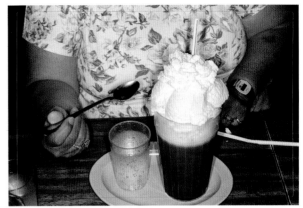
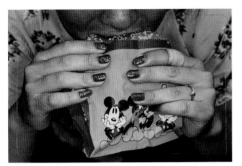
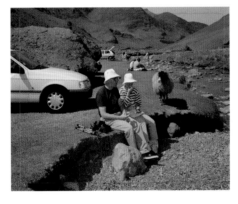
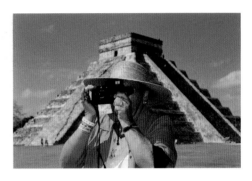

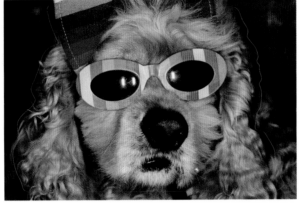
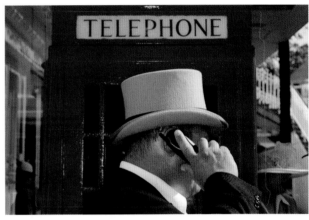
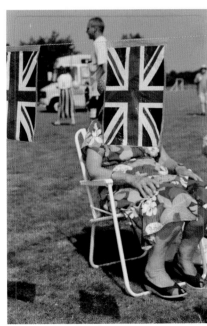
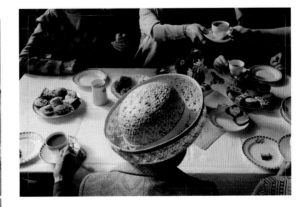
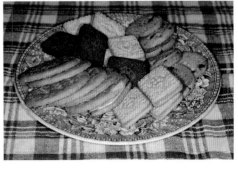
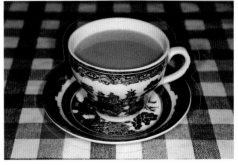

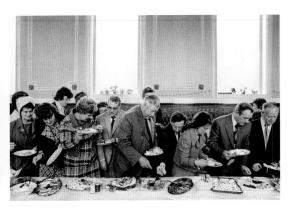
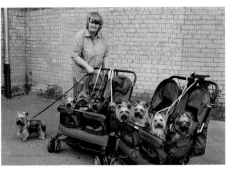
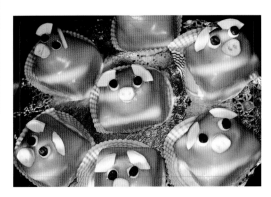
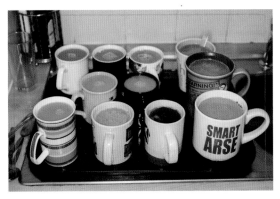
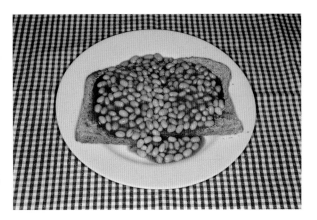
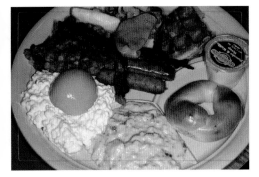
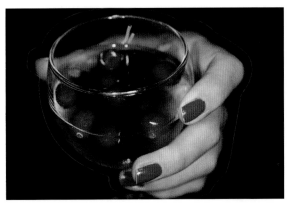
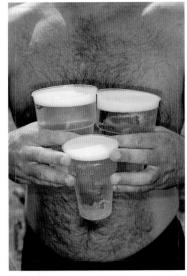
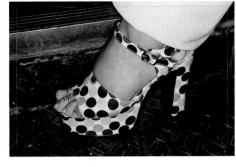

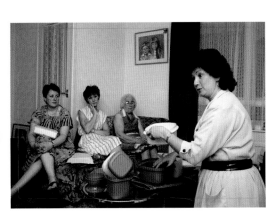
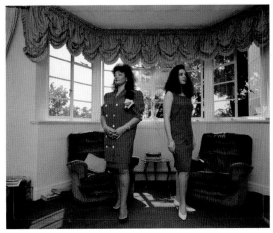

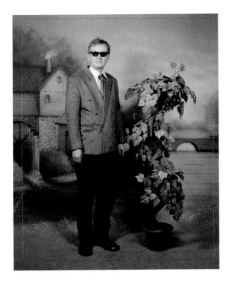

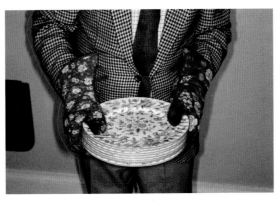

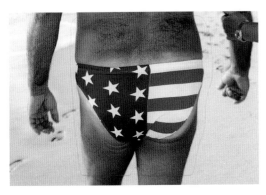

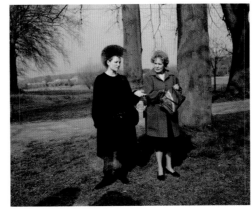

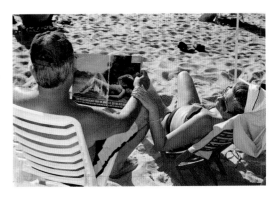

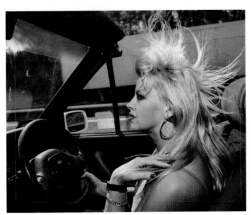

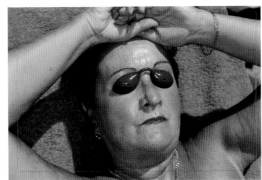

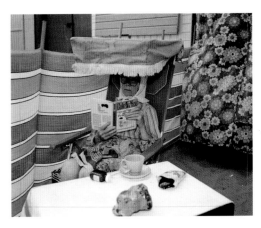

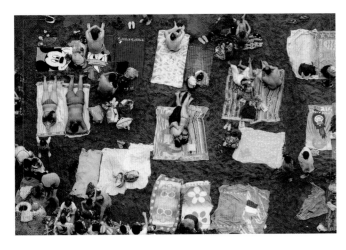

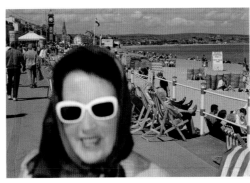

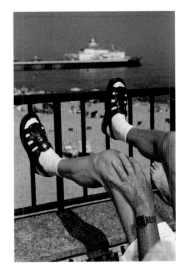